Remembering
Cincinnati

T0169587

Linda Bailey

TURNER
PUBLISHING COMPANY

The "Genius of Water" standing atop the Tyler Davidson Fountain is illuminated against the backdrop of the Carew Tower in the 1940s.

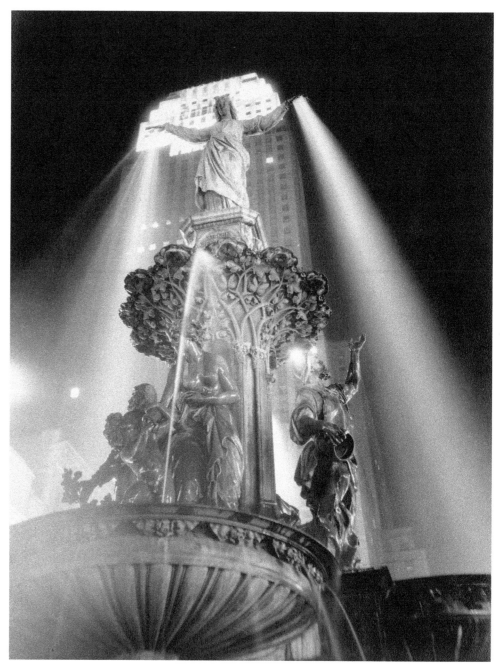

Remembering *Cincinnati*

Turner Publishing Company
www.turnerpublishing.com

Remembering Cincinnati

Library of Congress Control Number: 2010902274

ISBN: 978-1-59652-606-8

Printed in the United States of America

ISBN 978-1-68336-818-2 (pbk.)

CONTENTS

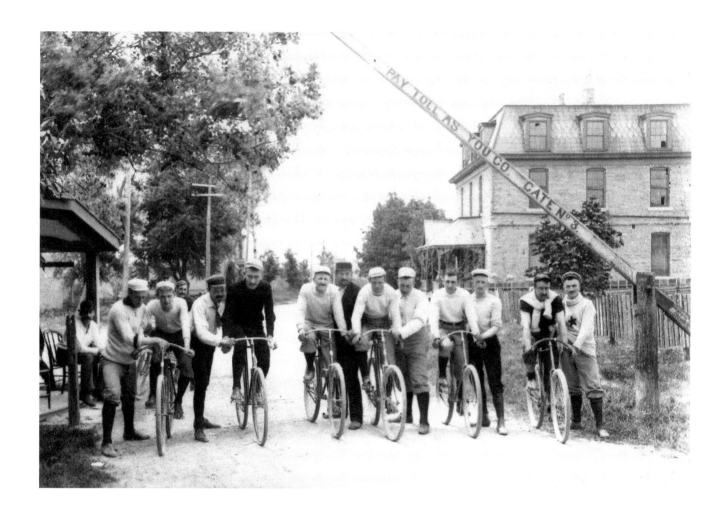

In the 1880s and 1890s, athletic and socially oriented bicycle clubs flourished. Brighton Bicycle Club members are lined up for the start of a race from Glendale to Hamilton in 1892.

Acknowledgments

This volume, *Remembering Cincinnati*, is the result of the cooperation and efforts of many individuals, organizations, and corporations. It is with great thanks that we acknowledge the valuable contribution of the following for their generous support:

Cincinnati Museum Center
Taft, Stettinius & Hollister LLP
US Bank

We would also like to thank the following members of the staff of Cincinnati Museum Center for their valuable contribution and assistance in making this work possible:

Daniel Hurley, Assistant Vice President for History
Scott Gampfer, Director of History Collections—Chapter Essays
Tina Bamert, Scanning Technician—Scanning
Ruby Rogers, Library Director—Fact Checking and Proofreading
M'Lissa Kesterman, Reference Librarian—Fact Checking and Proofreading
Anne Shepherd, Reference Librarian—Fact Checking and Proofreading
Laura Chace, Reference Librarian—Fact Checking and Proofreading

PREFACE

Cincinnati has thousands of beautiful and important historic photographs. This book began with the observation that, while those photographs are of great interest to many, they are not easily accessible. During a time when Cincinnati is looking ahead and evaluating its future course, many people are asking, How do we treat the past? These decisions affect every aspect of the city—architecture, public spaces, commerce, and infrastructure—and these, in turn, affect the way that people live their lives. This book seeks to provide easy access to a valuable, objective look into the history of Cincinnati.

The power of photographs is that they are less subjective than words in their treatment of history. Although the photographer can make subjective decisions regarding subject matter and how to capture and present it, photographs seldom interpret the past to the extent textual histories can. For this reason, photography is uniquely positioned to offer an original, untainted look at the past, allowing the viewer to learn for himself what the world was like a century or more ago.

This project represents countless hours of review and research. The researchers and authors have reviewed thousands of photographs from the Cincinnati Museum Center Archives. We greatly appreciate the generous assistance of the archivists listed in the acknowledgments of this work, without whom this project could not have been completed.

The goal in publishing this work is to provide broader access to this set of extraordinary photographs that seek to inspire, provide perspective, and evoke insight that might assist people who are responsible for determining Cincinnati's future. In addition, the book seeks to preserve the past with adequate respect and reverence.

With the exception of touching up imperfections that have accrued with the passage of time and cropping where necessary, no changes have been made. The focus and clarity of many images are limited to the technology and the ability of the photographer at the time they were recorded.

The work is divided into eras. Beginning with some of the earliest known photographs of Cincinnati, the first section records photographs from the eve of the Civil War through the end of the nineteenth century. The second section spans the beginning of the twentieth century through the years following World War I. Section Three moves from the Roaring Twenties through the Great Depression. The last section covers World War II to the 1950s. In each of these sections we have made an effort to capture various aspects of life through our selection of photographs. People, commerce, transportation, infrastructure, religious institutions, and educational institutions have been included to provide a broad perspective.

We encourage readers to reflect as they go walking in Cincinnati, along the Ohio riverfront, or along Vine Street, or through parks and neighborhoods hidden in the hills. It is the publisher's hope that in utilizing this work, longtime residents will learn something new and that new residents will gain a perspective on where Cincinnati has been, so that each can contribute to its future.

—*Todd Bottorff, Publisher*

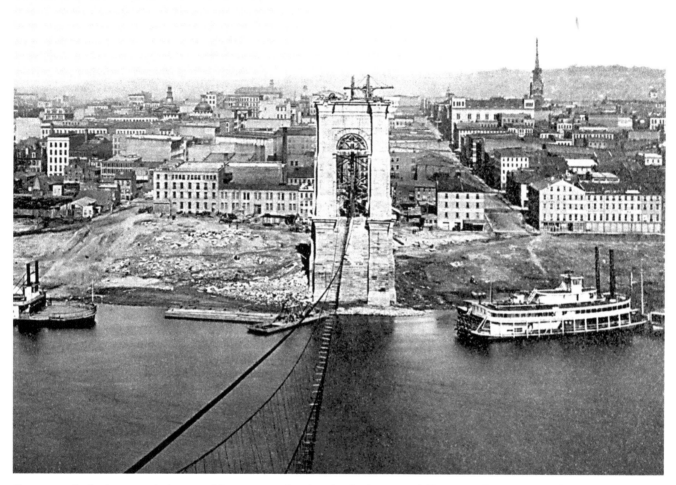

Center panel of a three-panel photographic panorama showing the Covington and Cincinnati Suspension Bridge under construction in 1865. Designed by master engineer John A. Roebling, the bridge was a prototype for New York's Brooklyn Bridge.

FROM CIVIL WAR TO THE DAWN OF A NEW CENTURY

(1860–1899)

The Sixth Street market stretched from Central to Vine Street from 1826 to 1959. The huge market consisted of two market houses, one for meat, poultry and dairy products, and the other was filled with colorful flower stalls. Both were surrounded by fruit and vegetable stands that lined both sides of the street.

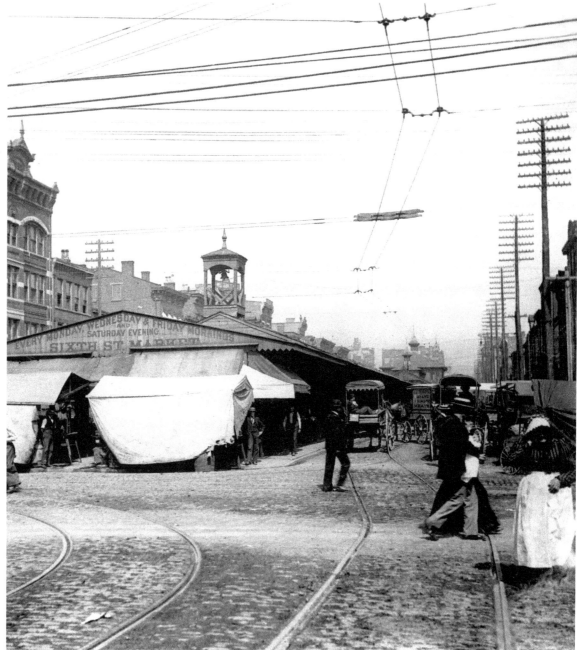

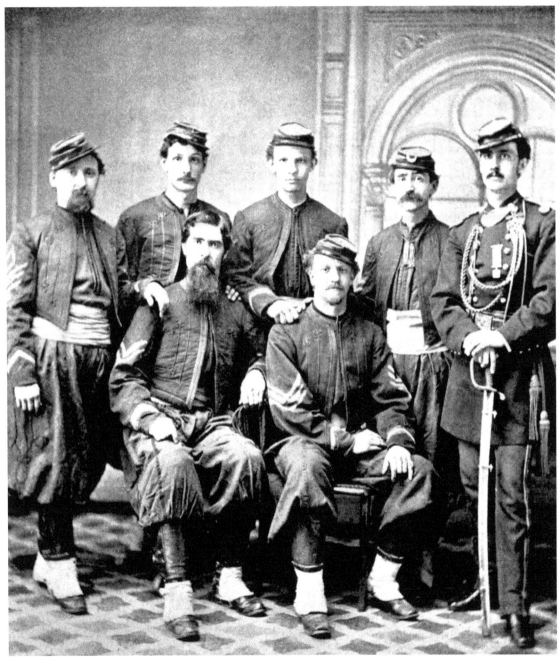

A group of men from Company B of the "Cincinnati Zouaves" pose for their portrait in 1868. An independent military organization, the Zouaves were known for their colorful uniforms consisting of dark blue jackets, scarlet baggy flannel trousers, and red fatigue caps.

Smartly attired Cincinnatians read the daily newspaper on the Commercial Gazette Building at Fourth and Race streets in 1882. The area was known as "Ladies Square" for its fashionable shops.

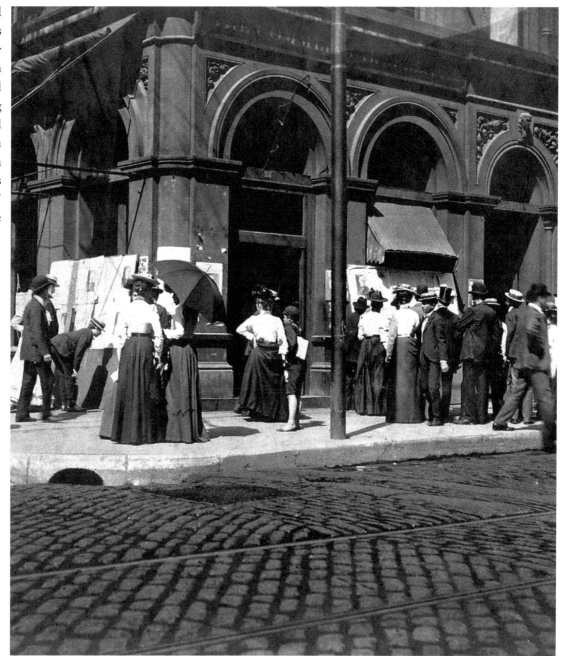

The last horse-drawn streetcar on Fourth Street passes in front of the Rombach and Groene photograph studio about 1892.

Employees working in the General Office of the Procter and Gamble Company in 1892. This office was located on an upper floor of the United Bank Building at Third and Walnut streets.

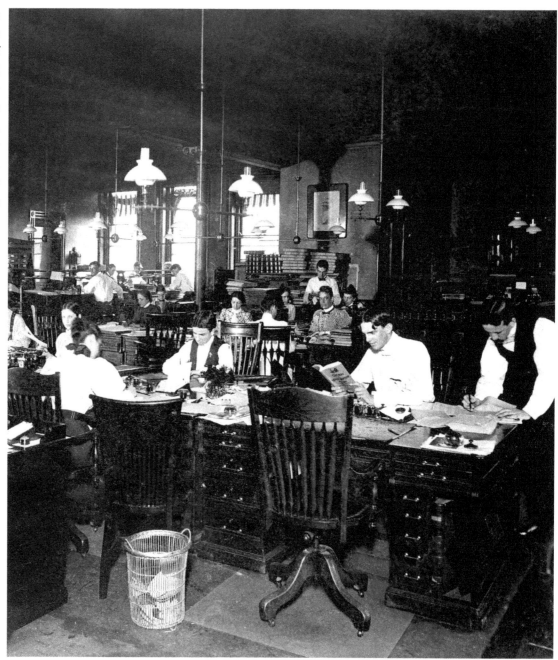

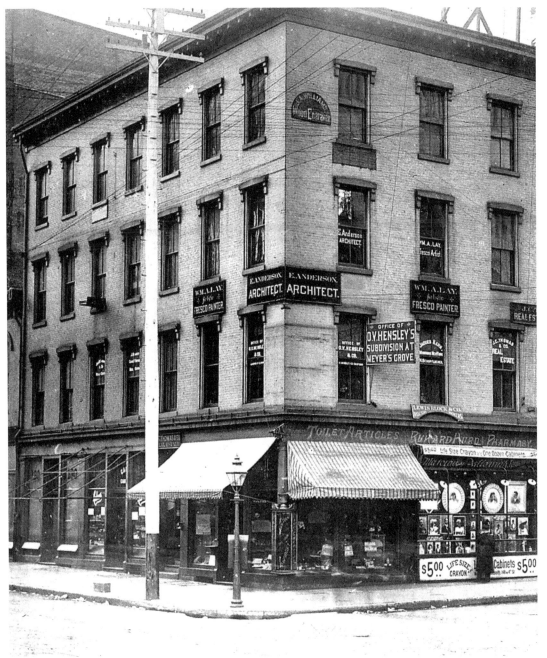

This multi-function office building stood on the northwest corner of Fourth and Race streets. It housed offices of the architect Edwin Anderson, fresco painter, William Lay, and realtor J. C. Thomas, as well as Hurd's Pharmacy and the studio of photographers Marceau and Bellsmith. The building was replaced by the Neave Building in 1891.

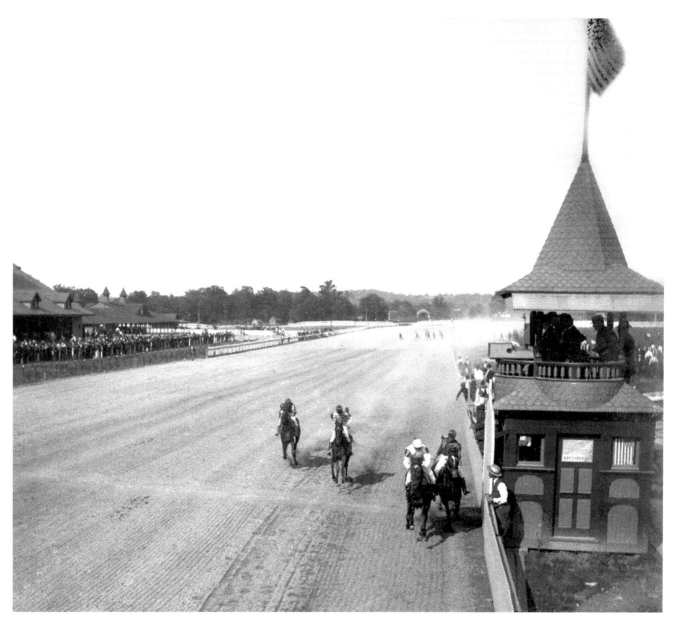

In the 1890s thoroughbred races replaced trotting at the Oakley Race Track. This photo shows the finish of the "Prince Leaf" race in 1896. Eventually, allegations of crooked gambling forced the track to close.

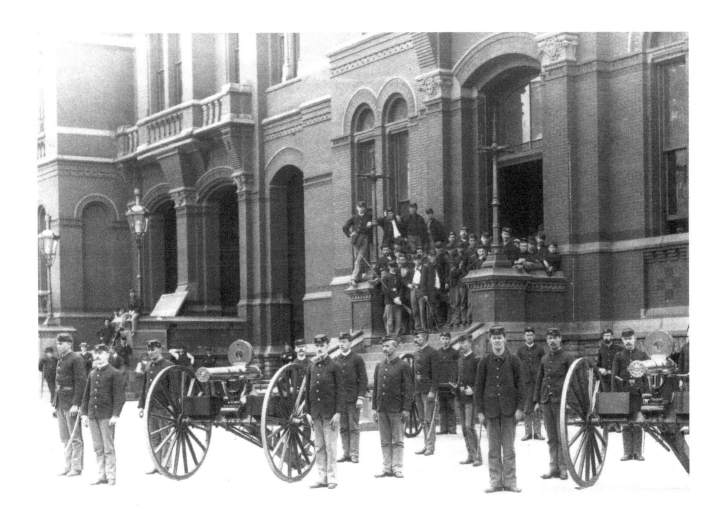

Ohio National Guardsmen with their Gatling guns pose in front of Music Hall following the Courthouse Riot in March 1884. The mere presence of the Gatling gun tended to have a calming effect on the frenzied mobs.

A makeshift barricade of planks and overturned wagons was hastily thrown together during the 1884 Courthouse Riot to protect the Hamilton County Jail.

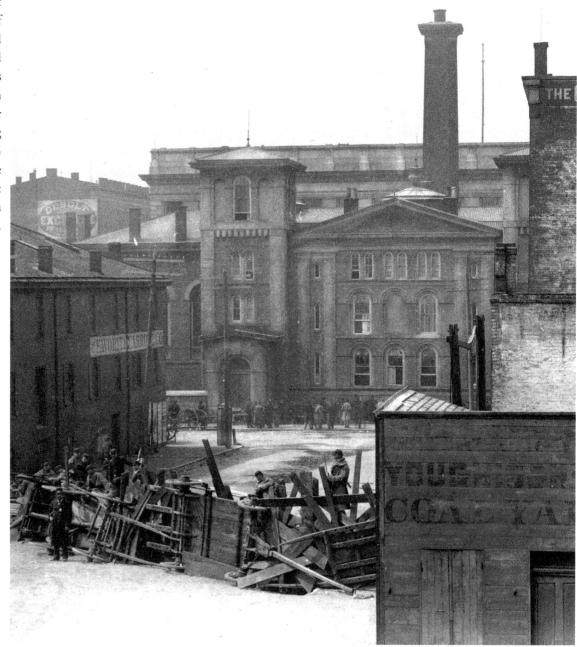

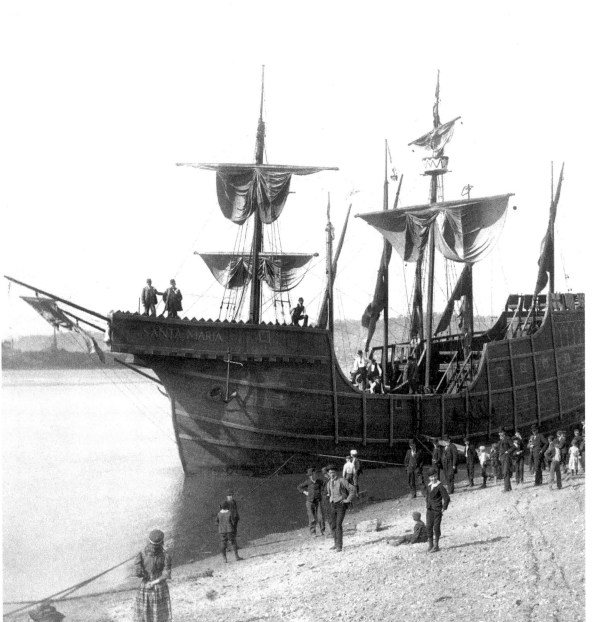

A replica of the *Santa Maria* took part in a river pageant on October 21, 1892 in honor of the 400th anniversary of Christopher Columbus' voyage to the new World.

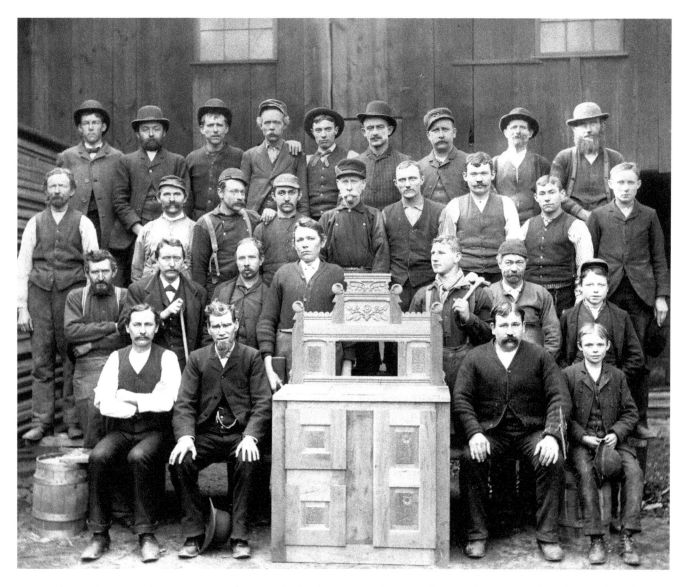

Joseph W. Wayne was the western manufacturer of Schooley's patented self-ventilating refrigerators, which kept perishable items fresher. Besides refrigerators, they also manufactured washboards, folding tables, beer coolers, and roller skates from 1866 to 1898.

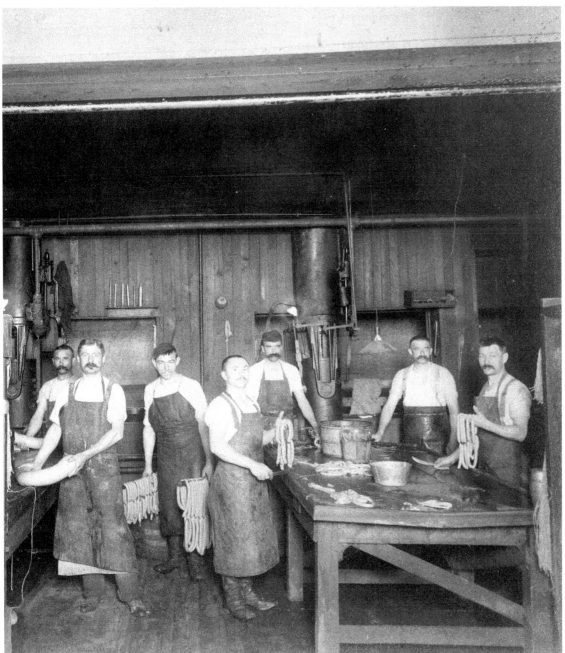

Throughout the 1800s the meatpacking industry in Cincinnati was so successful the city was given the moniker "Porkopolis". In 1880 there were 68 pork and beef packers and 25 sausage makers in the city.

The Hargrave family celebrated the Fourth of July in 1885 by playing tennis in their side yard.

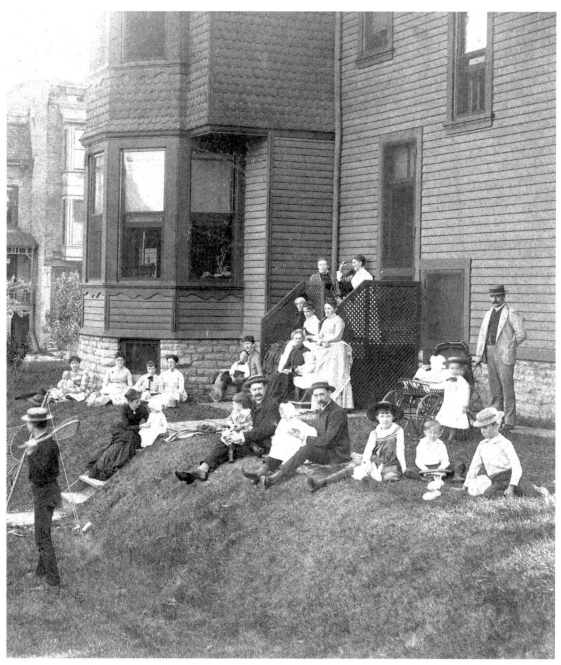

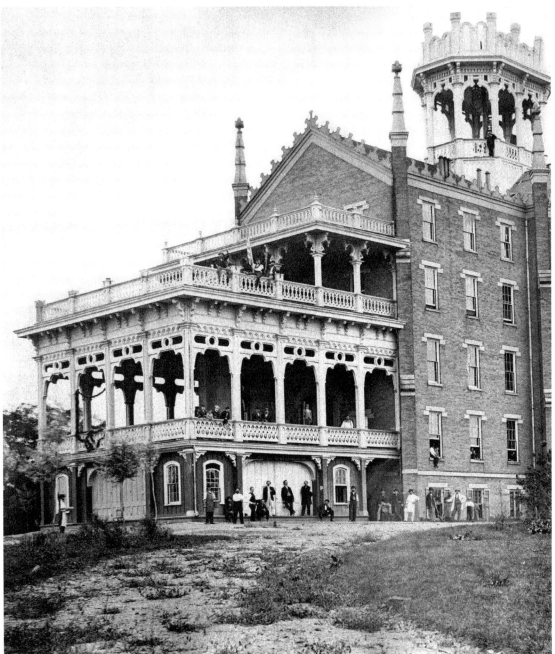

Originally a Baptist Seminary in 1866, this building became the home of the Schuetzen Verein, the German Shooting Society. In 1868 a beer garden, picnic grounds, and bowling alley were added. It was driven out of business by other hilltop venues accessible by inclines.

Max Wocher & Sons Company began manufacturing bowie knives and other cutlery. They grew into one of the largest suppliers of hospital furniture, surgical instruments, and orthopedic appliances. Seen here is the sewing room about 1896.

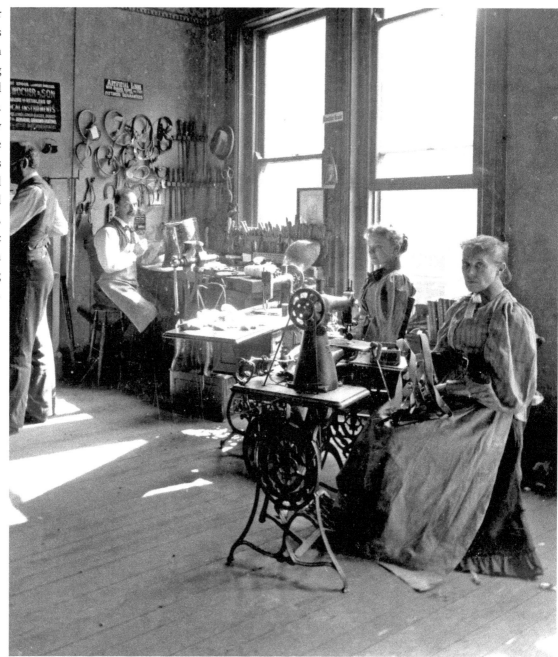

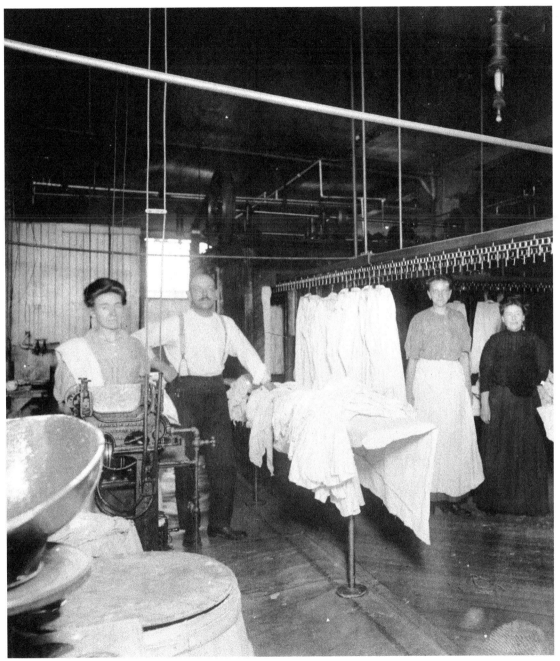

The White Star Laundry at Ninth and Sycamore employed 50 people in 1886 using the finest equipment known. In 1888 they received the only medal ever given to a laundry.

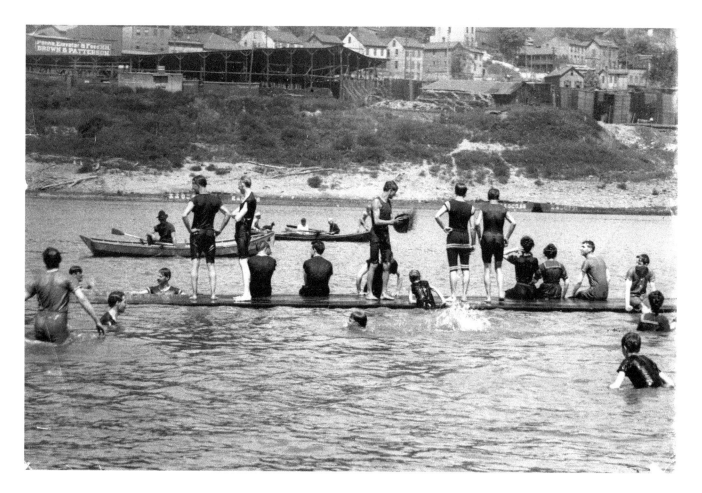

Around the turn of the century crowds of bathers on the beaches of Dayton and Bellevue, Kentucky, could be seen from the Cincinnati shore of the Ohio River.

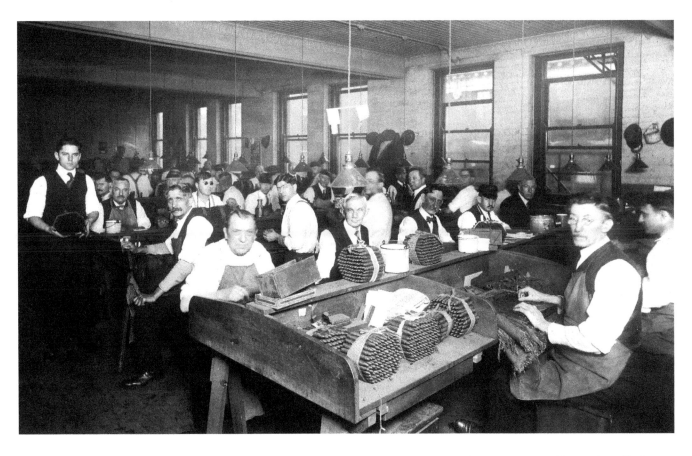

The Ibold Cigar Company was founded in 1884 by Michael Ibold. The company was the nation's second-largest broadleaf cigar maker. These men would each make an average of 250 cigars in an eight-hour day at the turn of the century.

Galvanized metal cans await shipment to the U.S. War Department in 1899. Originally manufacturers of roofing and cornices, the Witt Cornice Company expanded into the business of making fireproof cans to safely and sanitarily hold hot ashes and other garbage.

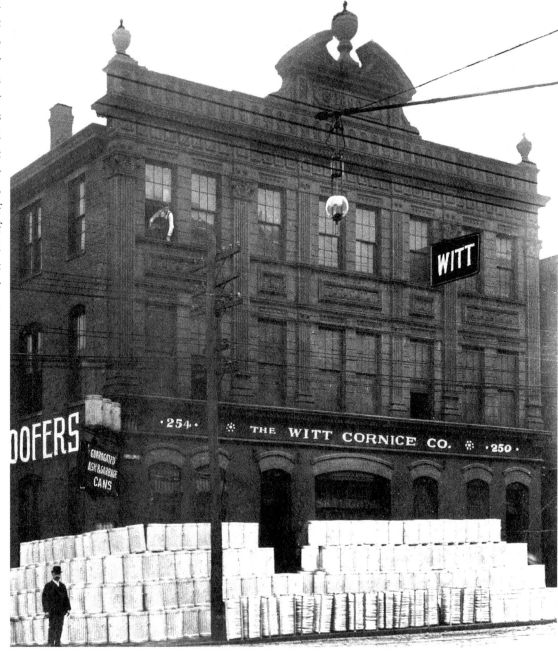

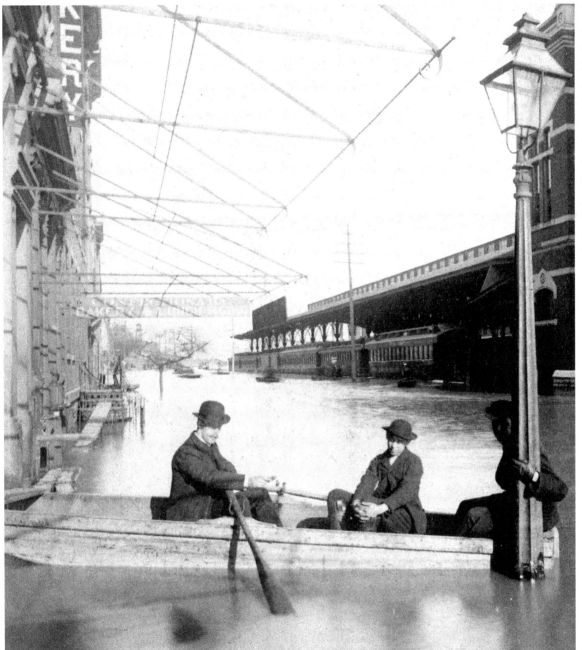

The view on Pearl Street as it looked facing east from Butler in 1884 during the second devastating flood in a year. The Ohio River crested at 71.1 feet.

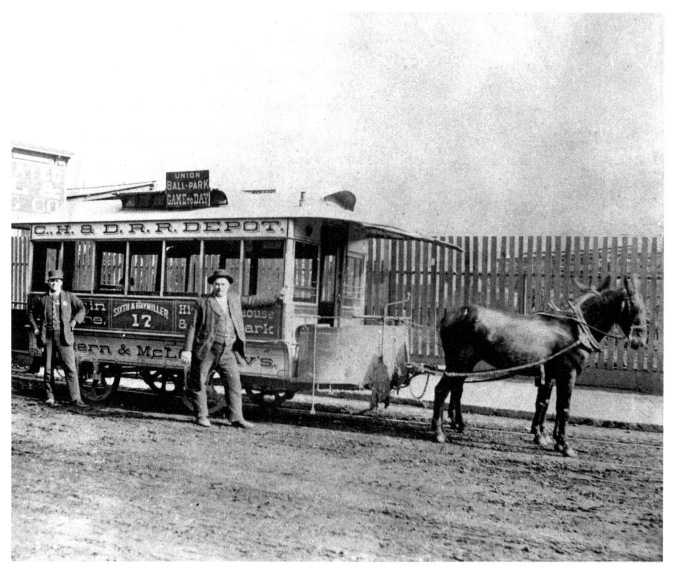

This mule-drawn streetcar is ready to escort fans to a baseball game at Union Park in 1883.

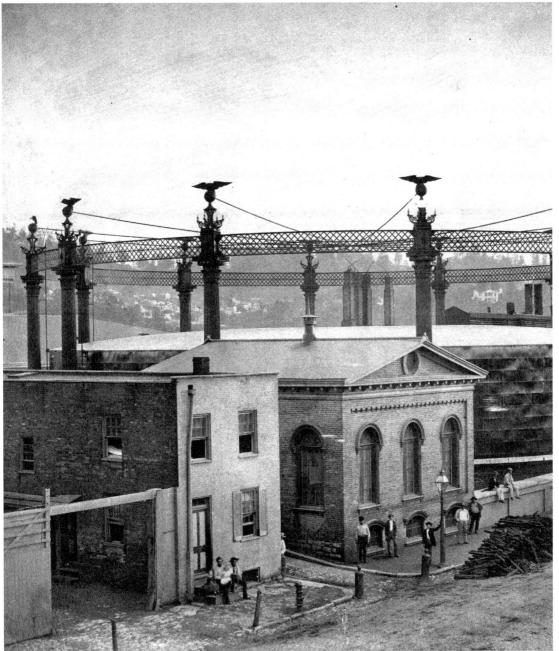

The Gas Works on Front Street west of Rose was built circa 1860 on the site called Hobson's Choice where General "Mad" Anthony Wayne trained his army in 1793.

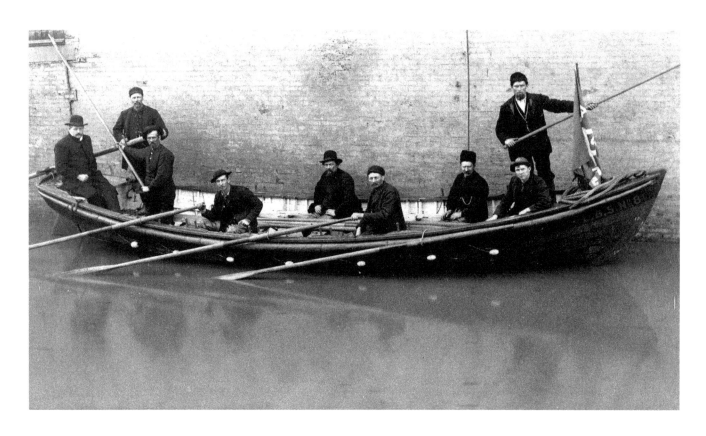

This U.S. Life Service boat and crew came to Cincinnati from Cleveland to assist with flood relief in 1883. They worked under the auspices of the Masonic Relief Committee of Cincinnati.

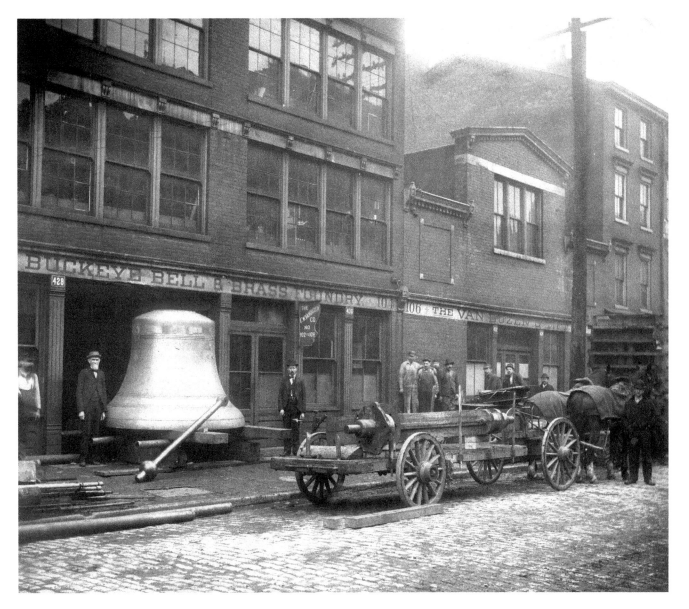

"Big Joe" is shown leaving the Buckeye Bell and Brass Foundry in 1895 en route to its home in the steeple of St. Francis de Sales Church. The massive bell was rung only once because the E-flat peal was so deafening it shattered windows and shook surrounding buildings.

Pneumatic or air-filled tires provided a more comfortable ride for bicyclists but were more prone to punctures. Members of the Brighton Bicycle Club became experts at changing tires.

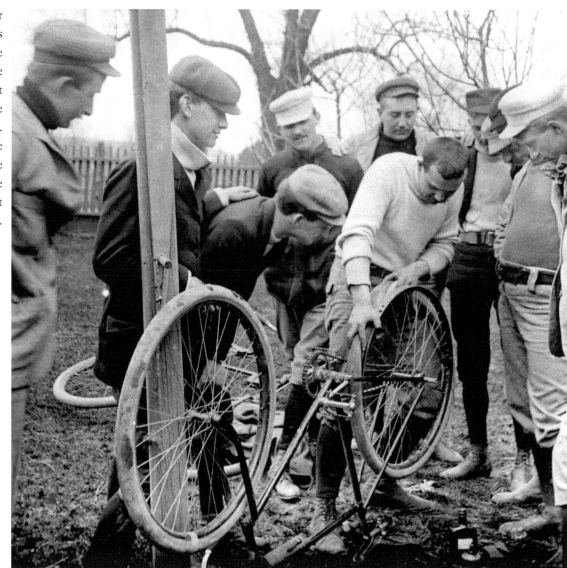

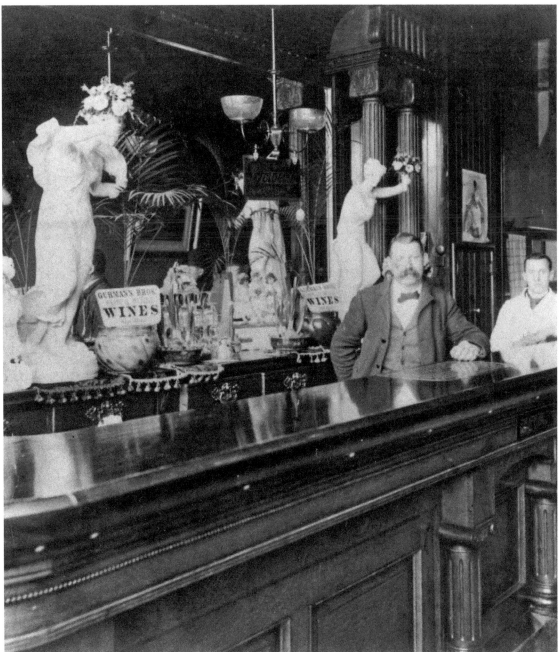

The Schwartz Saloon on McMicken Avenue was typical of the many neighborhood saloons that dotted the city in the late nineteenth century. In 1890 there were more than 1,800 saloons listed in the Cincinnati City Directory.

The last and most elaborate of Cincinnati's nineteenth-century industrial expositions was the Centennial Exposition of the Ohio Valley and Central States in 1888. With the Miami and Erie Canal converted into a Venetian waterway complete with gondolas, the exposition featured a spectacular production of the *Carnival of Venice*. Here, members of the cast pose for a photograph.

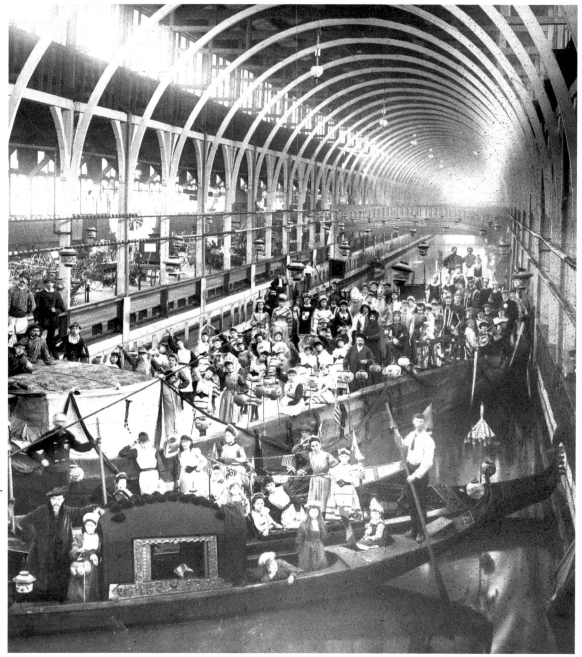

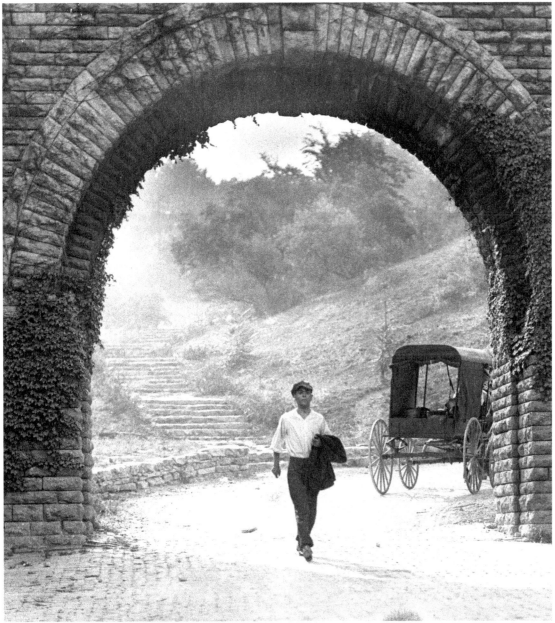

The archway of the Elsinore Tower once served as an entrance to Eden Park. Inspired by the castle in Shakespeare's *Hamlet,* the Elsinore Tower was built in 1883 as a valve house for use by the city waterworks to control the flow of water from the Eden Park Reservoir to the city below.

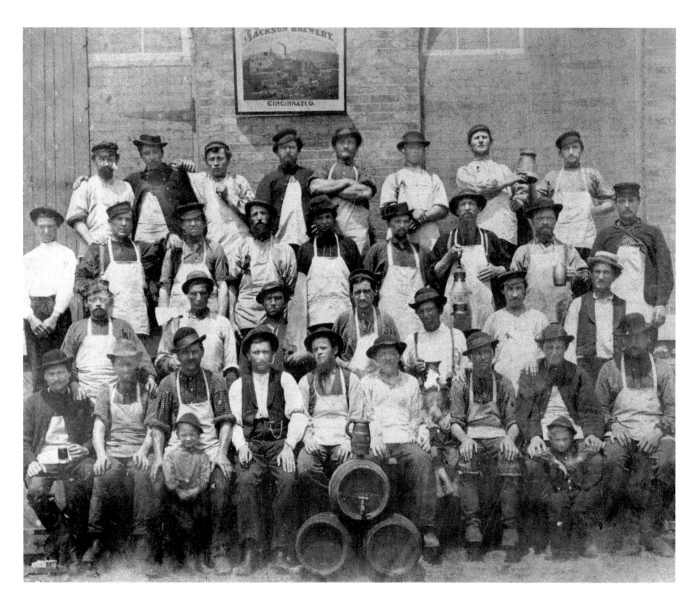

A group of men employed by the Jackson Brewery around 1870. In 1871 this brewery was the fifth-largest in Cincinnati.

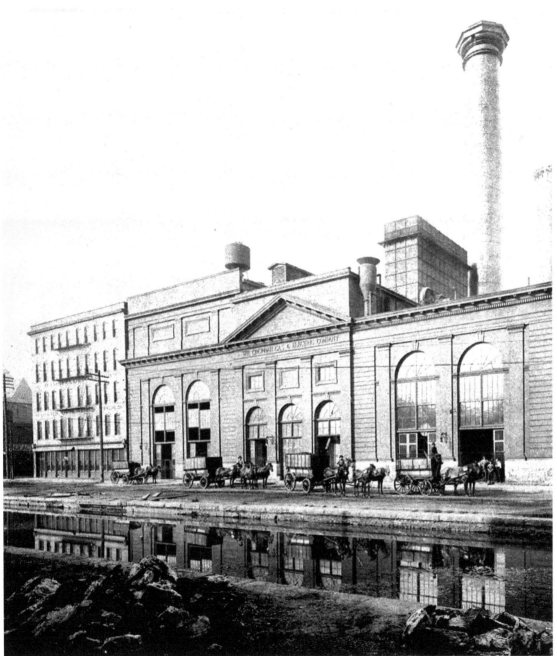

Wagons of coal are lined up in front of the Cincinnati Gas and Electric Company's Plum Street Power Station in the early 1900s. Located along the Miami and Erie Canal, this station had a generating capacity of 4,000 kilowatts when it first opened in 1899.

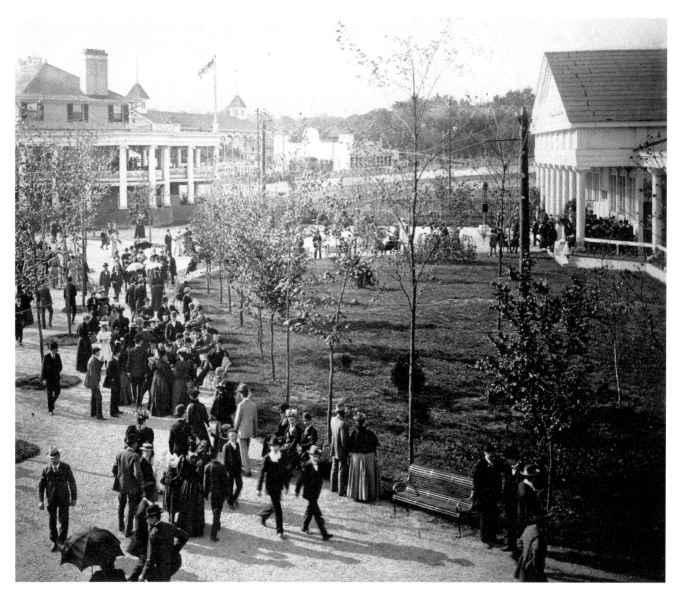

Adults and children alike enjoy a leisurely afternoon at Chester Park about 1898. This popular local amusement park opened in 1875; however, it was unable to survive the Great Depression and was forced to close in 1932.

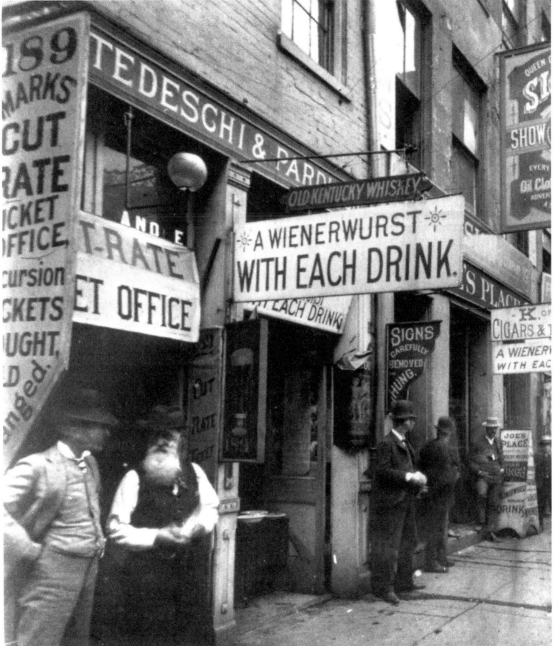

"Nasty Corner" was the name given to the southwest corner of Fifth and Vine streets in the 1890s because of the large number of saloons concentrated on that corner. The German influence in the city can be seen in the signage. The Carew Building and later Carew Tower were constructed on this site.

Workmen delivering electric generating equipment to the Ninth Street Substation of the Cincinnati Gas and Electric Company. In 1904 City Council fixed the maximum rate for electricity at eleven cents per kilowatt-hour.

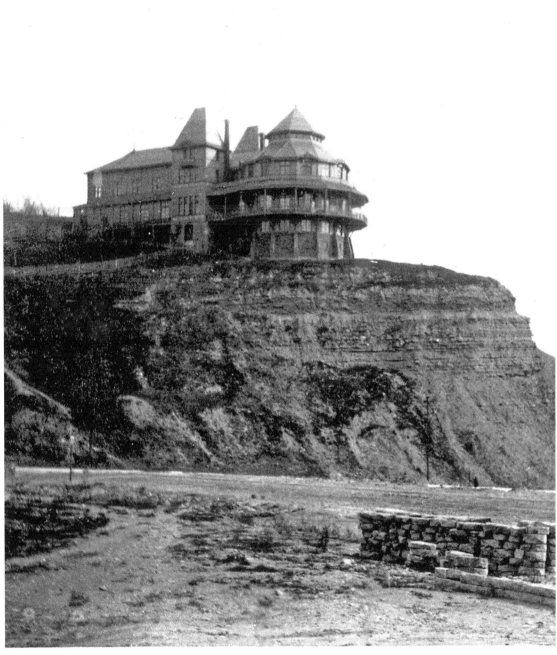

Designed by prominent local architect James W. McLaughlin and erected in 1876, the Bellevue House was located adjacent the Bellevue Incline, high above the smoke and heat of Cincinnati's basin area. This ornate hilltop resort provided its customers with food, drink, entertainment, and a sweeping view of the city until it finally went out of business around 1895.

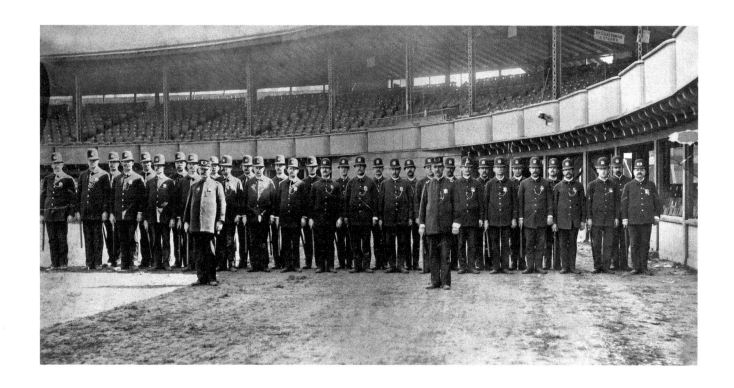

Beginning in 1887 the Cincinnati Police Force began staging an annual inspection, review, and parade to which the public was invited. Up until 1901, this yearly event was often held at League Park, which was the home of the Cincinnati Reds Baseball Club.

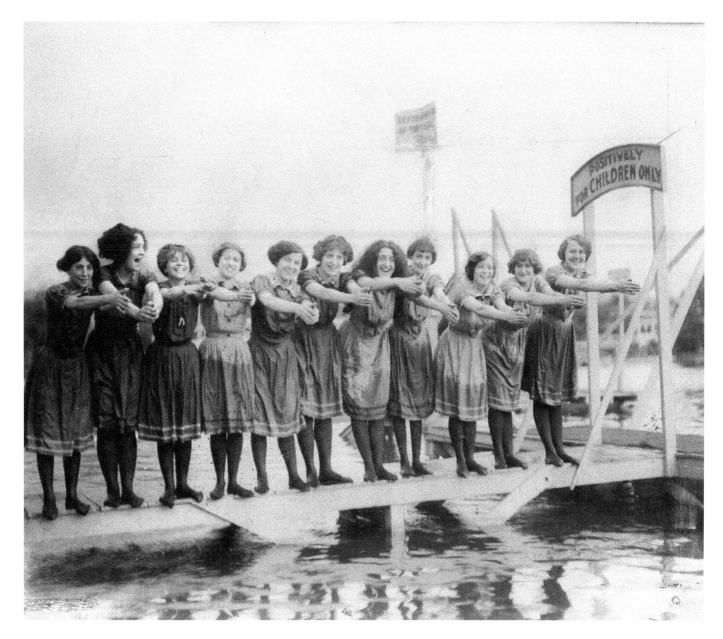

Bathing beauties line up for a dive in the refreshing water at Chester Park.

This bustling intersection at Fifth and Walnut streets was the scene of the Drach explosion in 1896. Escaping gasoline fumes caused a terrific explosion that resulted in the collapse of several buildings and a number of deaths.

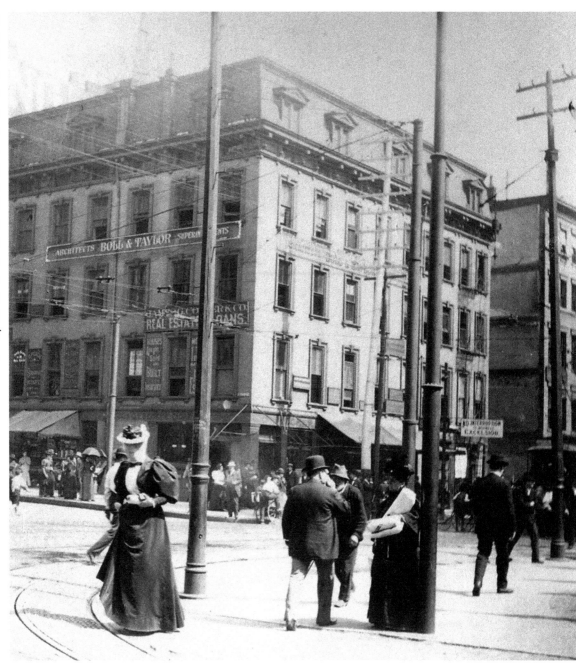

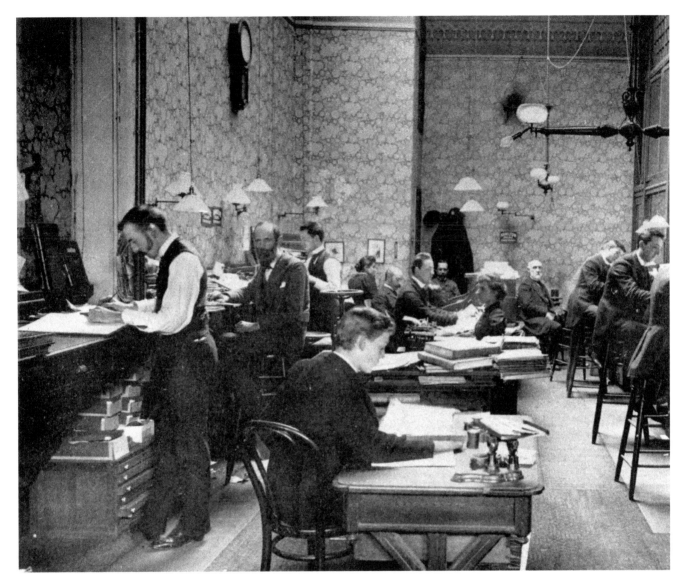

Clerks in the Walnut Street office of D. H. Baldwin and Company, piano manufacturers, are busy at work in September 1891. Business partners sat at the center-rear of the room.

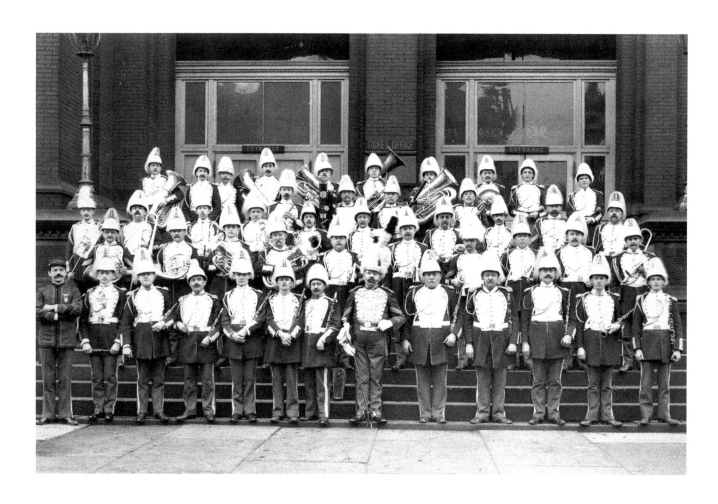

Smittie's Band, led by George G. Smith, stands in front of Music Hall. Four generations of Smiths have led the band in major parades, inaugurations, fairs, and concerts in the city.

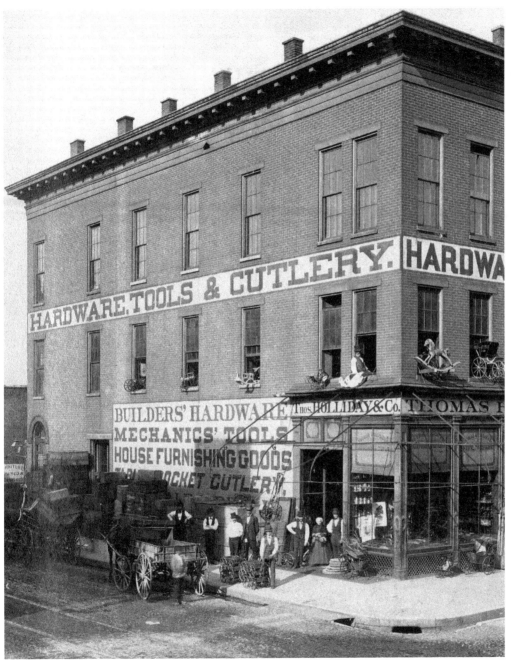

Thomas Holliday and Company on the northeast corner of Central Avenue and Fifth Street manufactured children's carriages and hobby horses as well as hardware and tools. In 1873, indoor photography outside of studios was difficult, so merchants set their wares on the street or hung them from windows to be photographed.

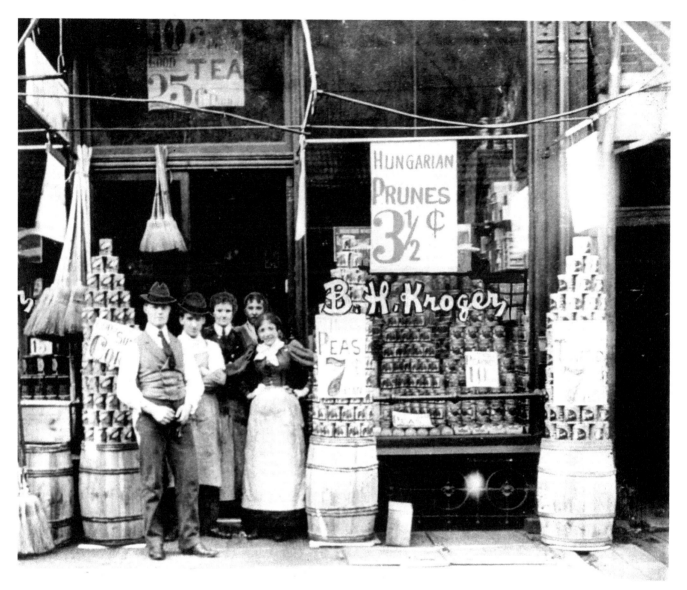

A large selection of canned goods is displayed in front of Barney Kroger's original grocery store. This store opened in 1883 at 66 Pearl Street, just opposite the Pearl Street Market House.

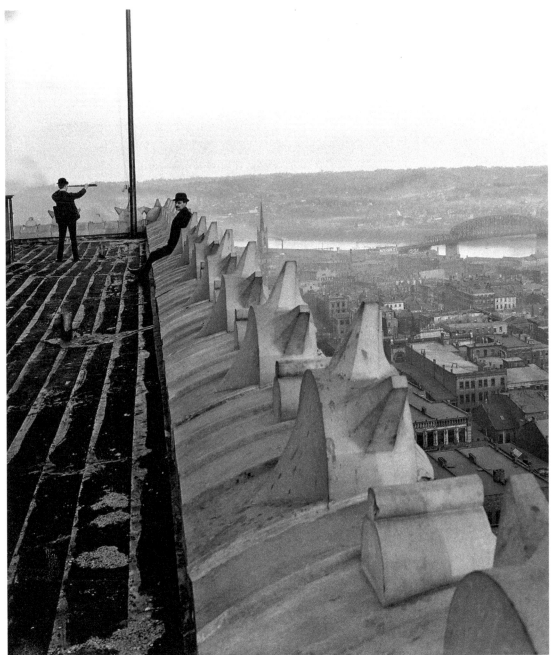

The view was expansive from Cincinnati's first "skyscraper" in 1901. From the top of the Union Savings Bank and Trust Company Building at Fourth and Walnut, one could look down into the smoky basin of the city or across to the rolling hills of the Bluegrass State.

Summer car 12 which served the Madison Road–Hyde Park route had nine benches with a seating capacity for 45 passengers. Open-sided streetcars such as this one provided a pleasant way to climb the hills of the Queen City on a hot summer day in the early 1900s.

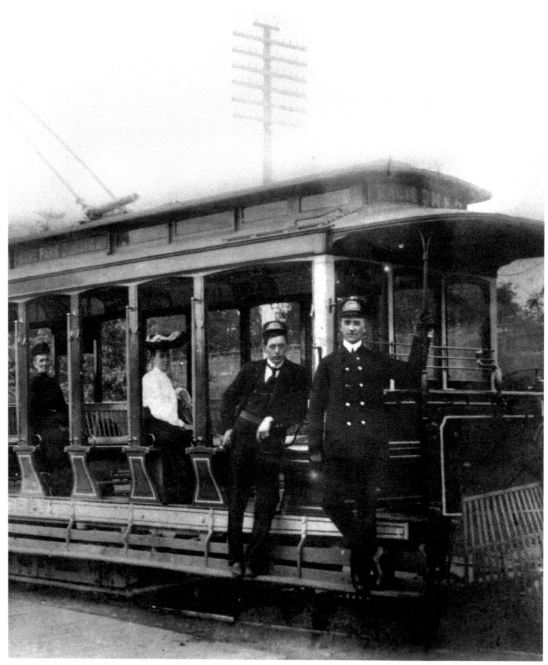

THE EXPANDING CITY
CINCINNATI ENTERS THE NEW CENTURY

(1900–1920)

Three hundred fleas and eight handsome choir boys performed side-by-side in the theater on the Coney Island midway at the turn of the century.

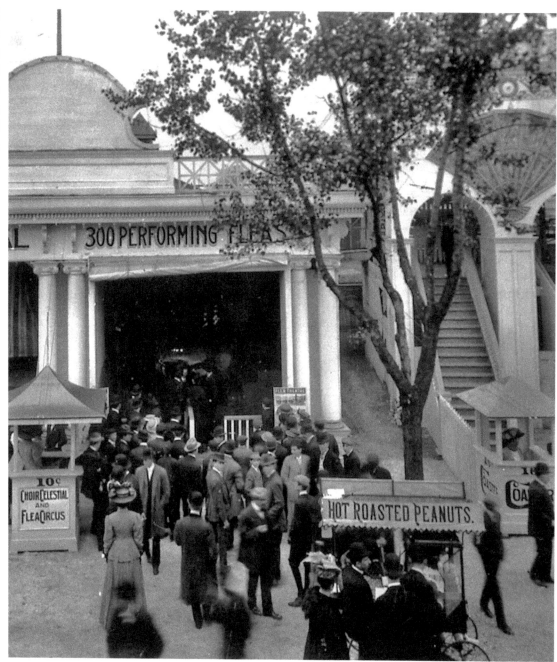

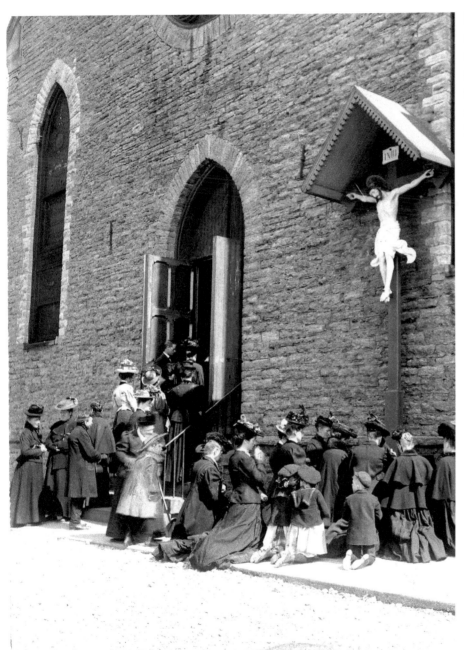

Roman Catholic faithful kneel to pray at the crucifixion shrine after climbing the 120 hillside steps to the Church of the Immaculata in Mt. Adams in the early 1900s. This Good Friday tradition has continued for close to 150 years.

In 1878 Cincinnati celebrated the completion of one of the finest and most beautiful music and exhibition halls in the world. Since that time Music Hall has been home to the Cincinnati Symphony Orchestra and its stage has been graced by the leading opera, ballet, and theater companies, as well as performances by musical artists and orators.

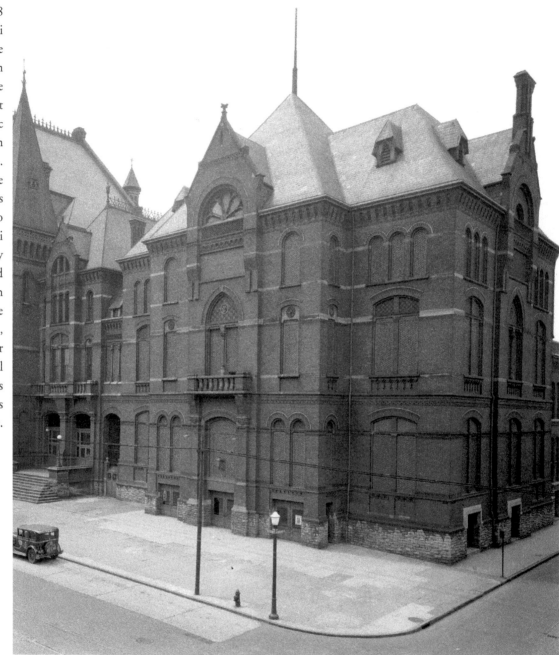

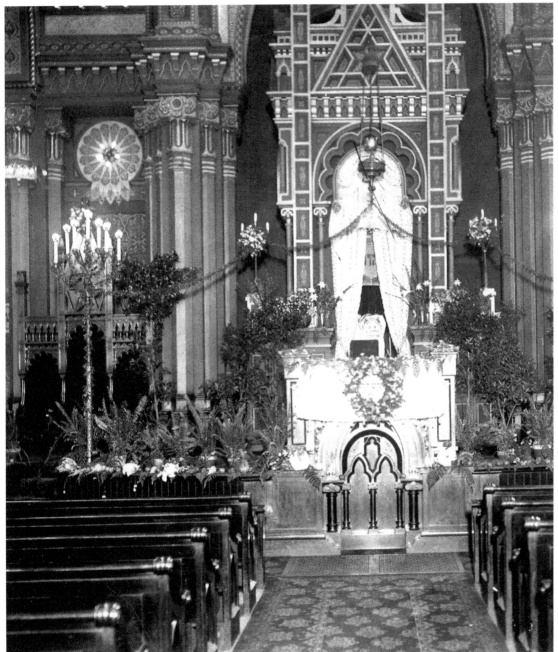

The elaborate neo-Gothic interior of the Plum Street (Isaac M. Wise) Temple retains many of the original features such as the flooring, pews, and pulpit furnishings. Chandeliers and other lighting fixtures, converted from gas to electricity, remain in use today. Completed in 1866 by the B'nai Yeshurun reformed congregation, this interior view shows the temple as it appeared in the early 1900s.

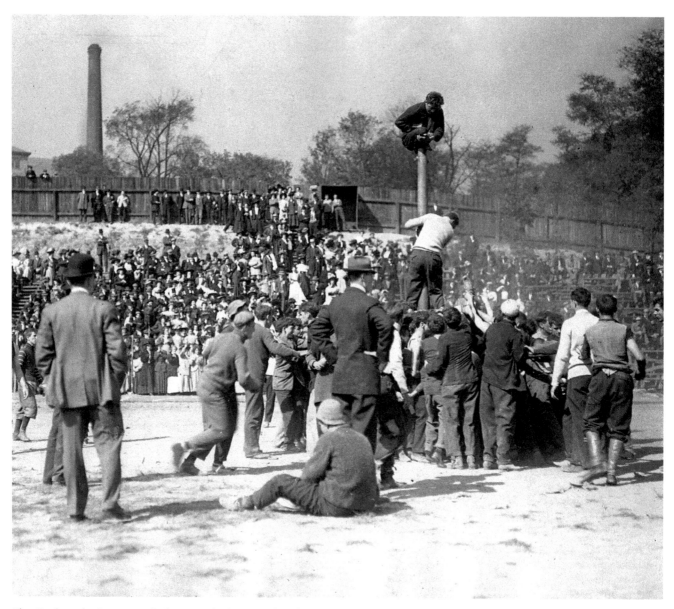

Flag Rush took place annually between freshmen and sophomores at the University of Cincinnati to determine physical superiority. The event was discontinued in 1913 because it was deemed too dangerous.

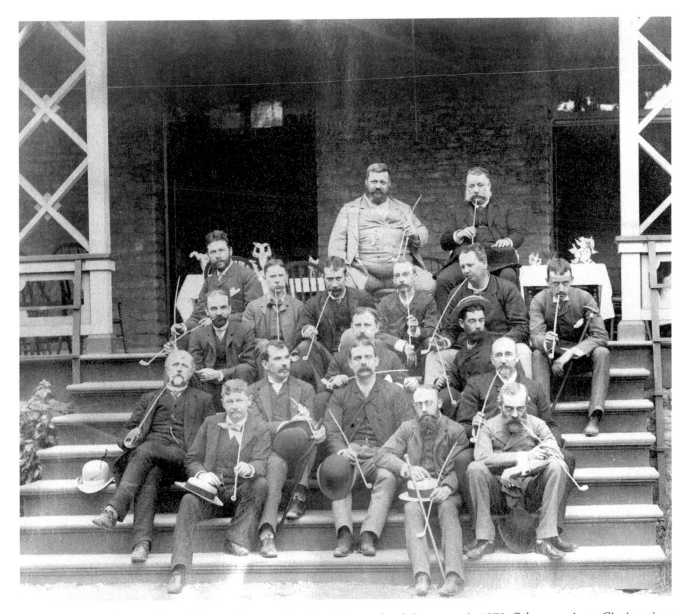

Four young lawyers began daily meetings over lunch at Hengstenberg's Restaurant in 1872. Other prominent Cincinnatians joined them and the group became known as the Hengstenberg Lunch Table. Anywhere from 2 to 12 men would meet daily for lunch and for a yearly formal meeting.

From 1900 to 1928 the Bode Wagon Company supplied wagons to all the major circuses to carry calliopes, animals, bands, and general equipment. Albert W. Bode stands next to a motorized circus wagon prior to World War I.

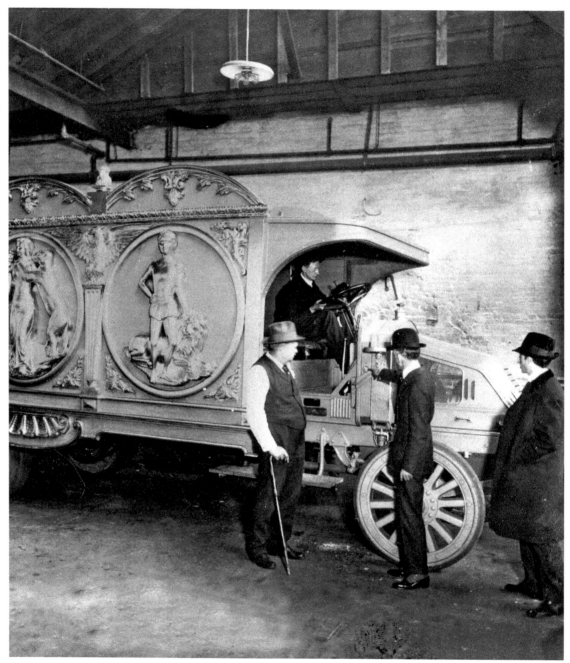

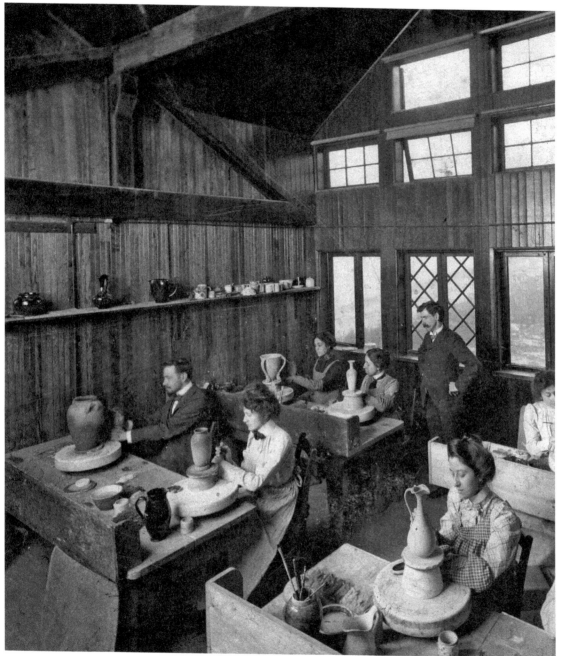

These artists are in the decorating room of Rookwood Pottery on Mount Adams. This picture was posed for use in the Paris Exposition of 1900. Today Rookwood is considered one of America's most collectible makers of art pottery.

In the early 1900s, a calligrapher prints visiting cards "while you wait" for 30 cents a dozen, with an additional 10 cents for addressing them.

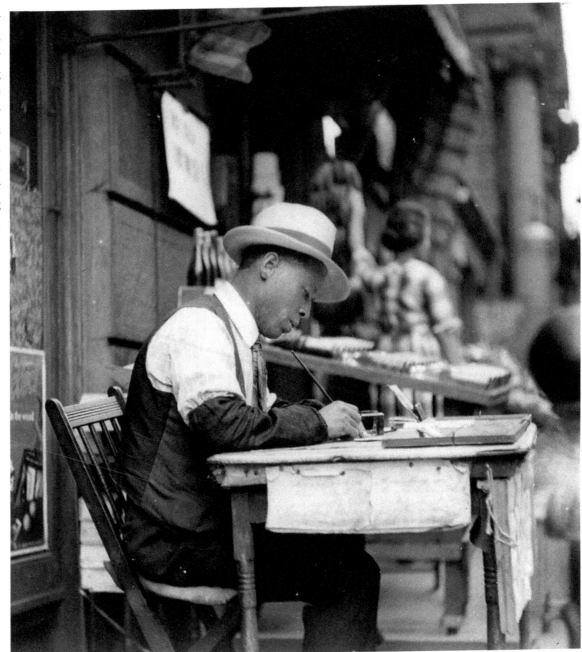

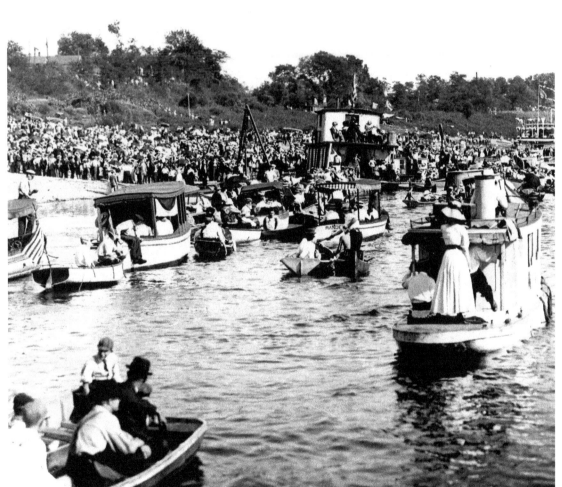

Colorful regattas attracted hundreds of spectators to the Ohio River at the turn of the century. Throngs lined the banks of the river, while others boarded small craft of their own to watch or participate in the race.

In the early twentieth century, selling newspapers on the street was one of the main jobs available to young boys. These newsboys await the baseball edition of the *Cincinnati Times-Star* to deliver on their bicycles.

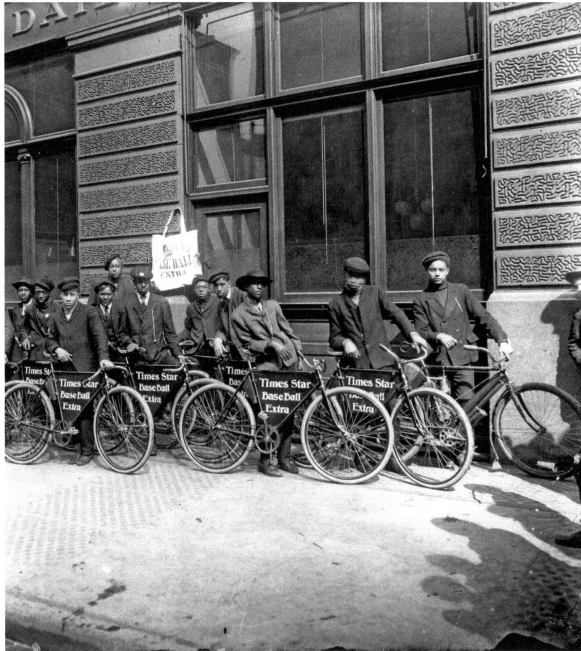

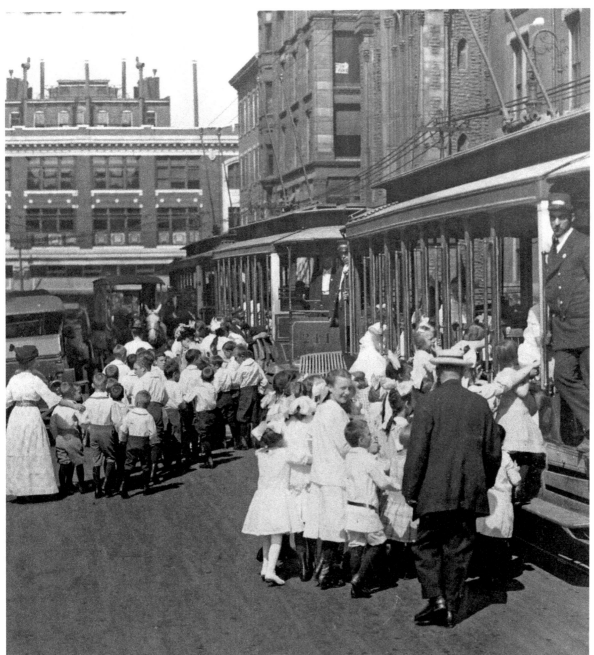

Residents of the Children's Home board streetcars for a day at the zoo.

The canal boat *West Carrollton* and her crew docked along the Miami and Erie Canal about 1905. This section of the canal later became Central Parkway.

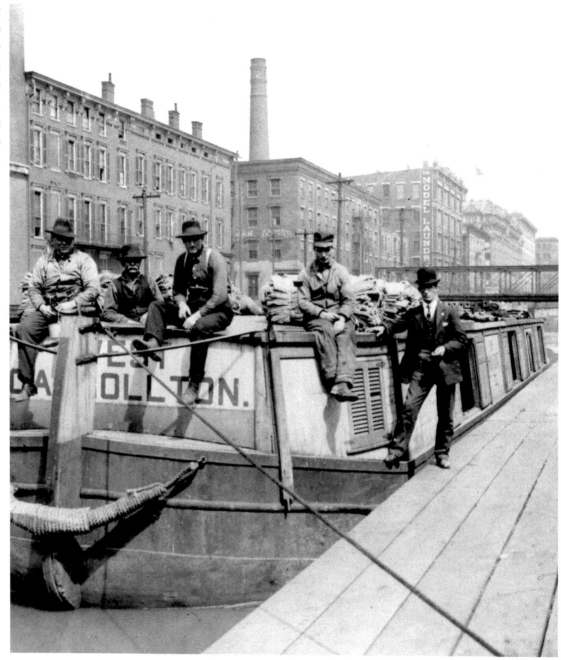

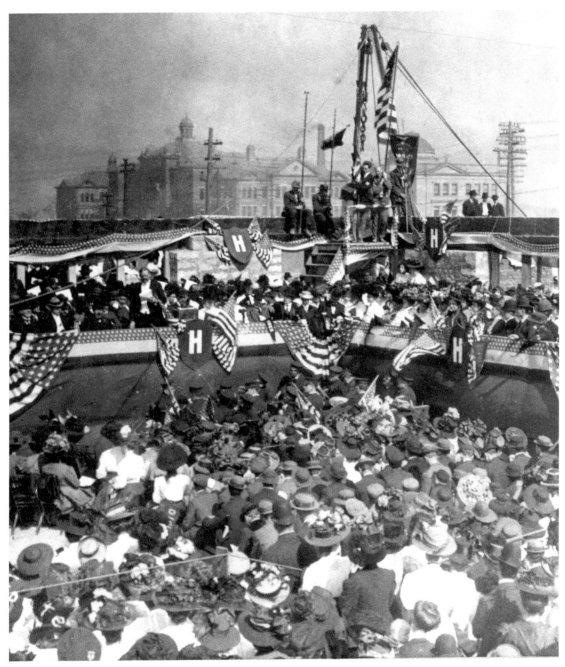

Hundreds watch the laying of the cornerstone of the new Hughes High School on October 16, 1908. This school as well as its predecessor was named for Thomas Hughes, a cobbler, who died in 1824 leaving his estate for the purpose of public education.

The Third National Bank and the Fifth National Bank consolidated under the name Fifth Third National Bank in 1908. Bank employees are seen here moving out of the Fifth National Bank's old headquarters shortly after the merger.

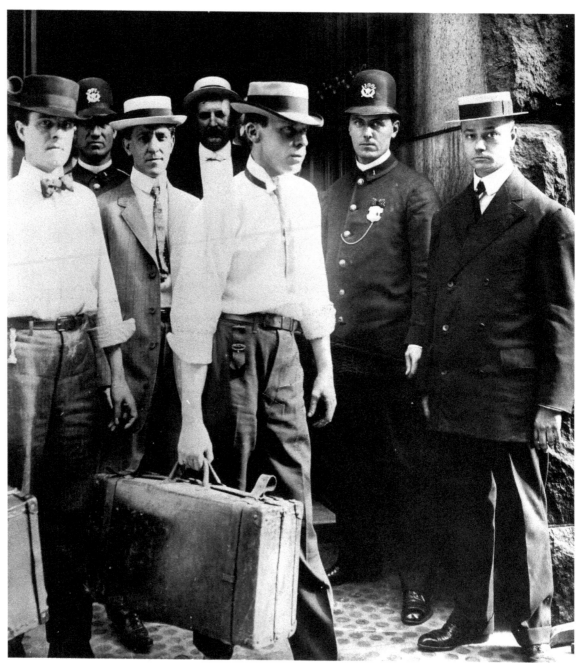

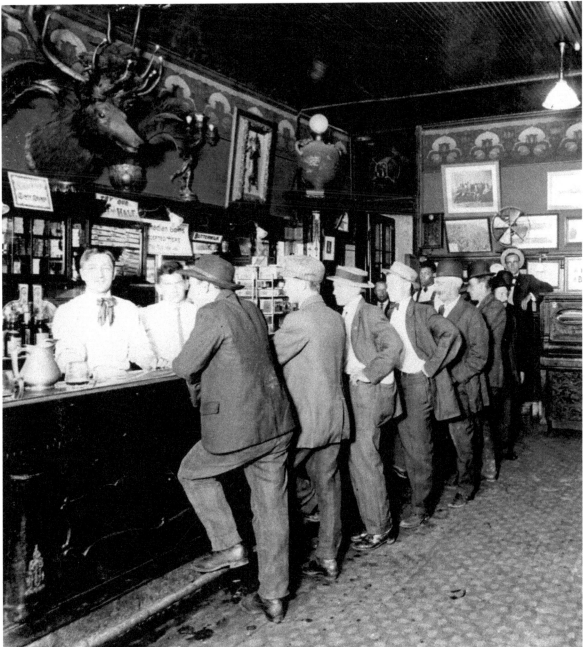

In 1910, one could drop a nickel in the slot of the nickelodeon and hear "a beautiful piano-piccolo duet" at the Garfield Cafe at Eighth and Vine streets.

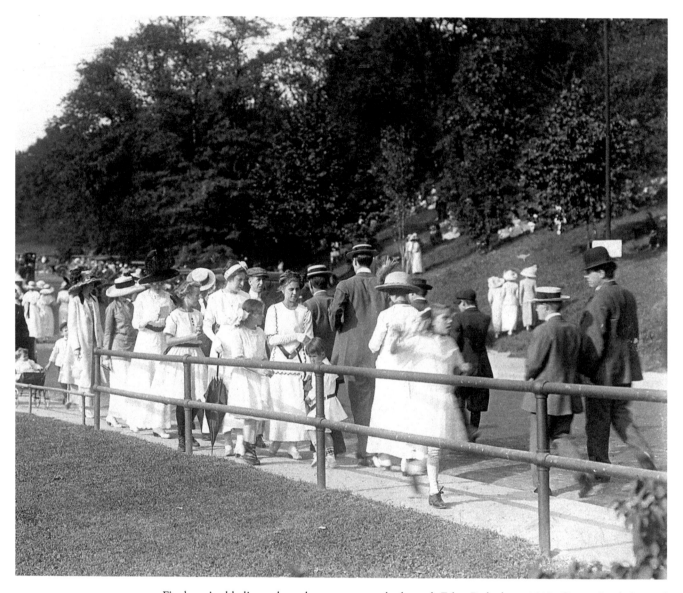

Finely attired ladies and gentlemen promenade through Eden Park about 1910. Conveniently located near the downtown district, Eden Park was a popular weekend destination that offered its visitors rolling landscaped hills and an impressive view of the Ohio River.

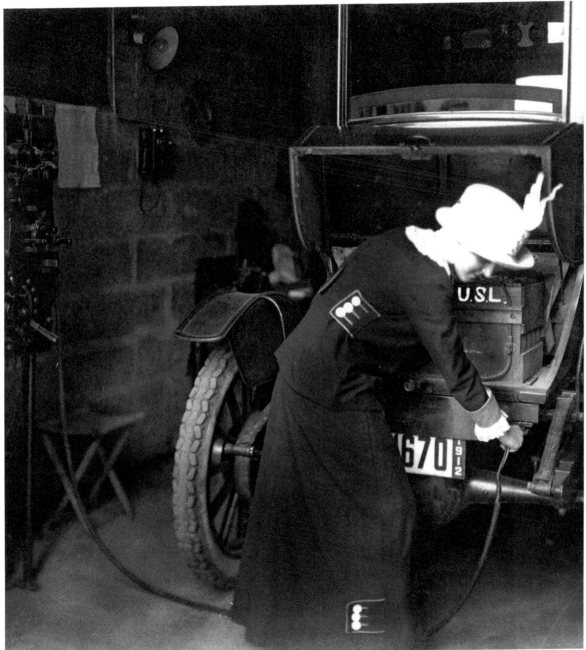

Charlotte Shipley charges up her car for a day's outing in 1912. Electric vehicles were popular in the early 1900s, especially among women, because engines didn't need cranking or gears shifted.

The new cement and iron Redland Field was designed by local architect Harry Hake and boasted the largest playing area in the major leagues when it opened in 1912. In 1934 the ballpark's name was changed to Crosley Field when radio magnate Powel Crosley, Jr., acquired control of the Cincinnati Reds.

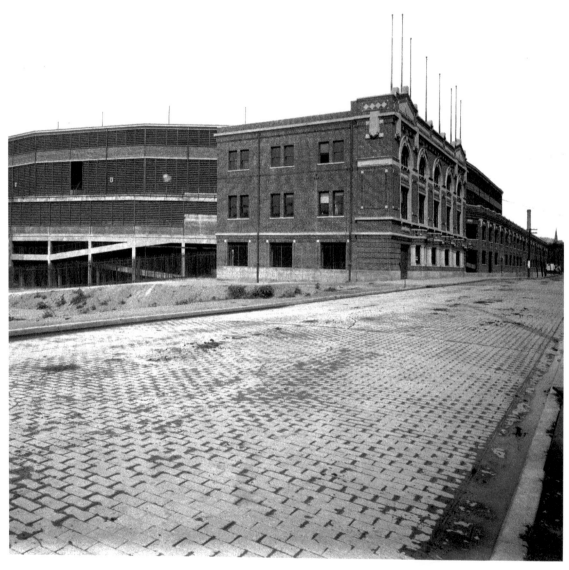

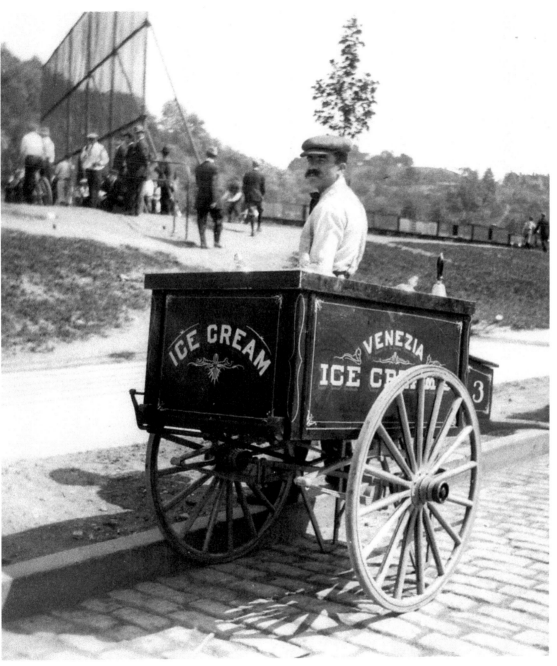

An ice cream vendor is waiting for business at the playground on Reading Road near Elsinore Place in 1913.

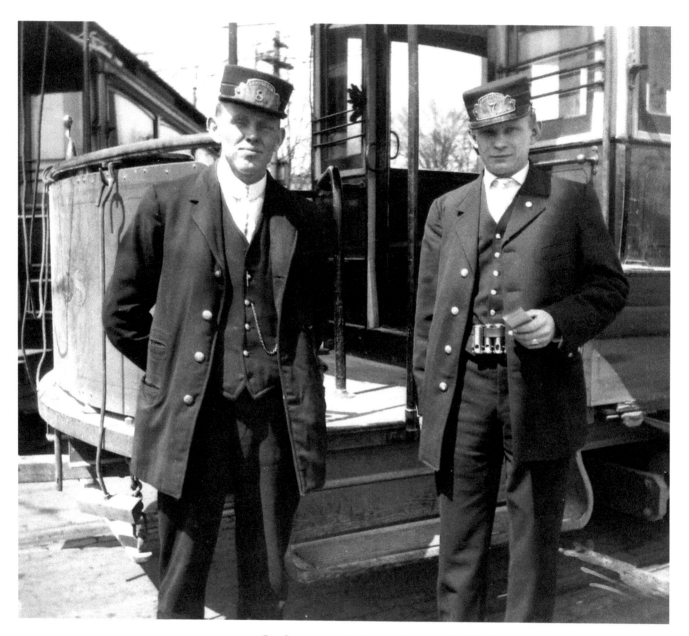

Conductors stand in front of a car on the Highland Avenue Streetcar line in 1913.

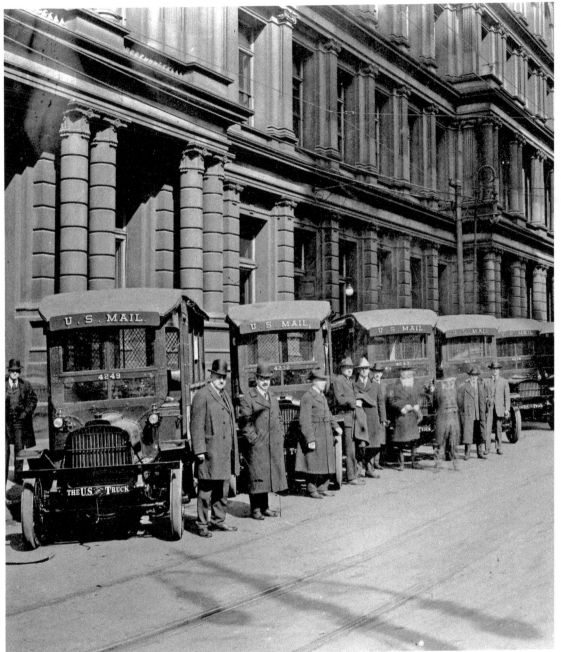

U.S. Mail delivery vehicles are lined up along the Fifth Street side of the Federal Office Building. Government owned and operated vehicle service began in 1914.

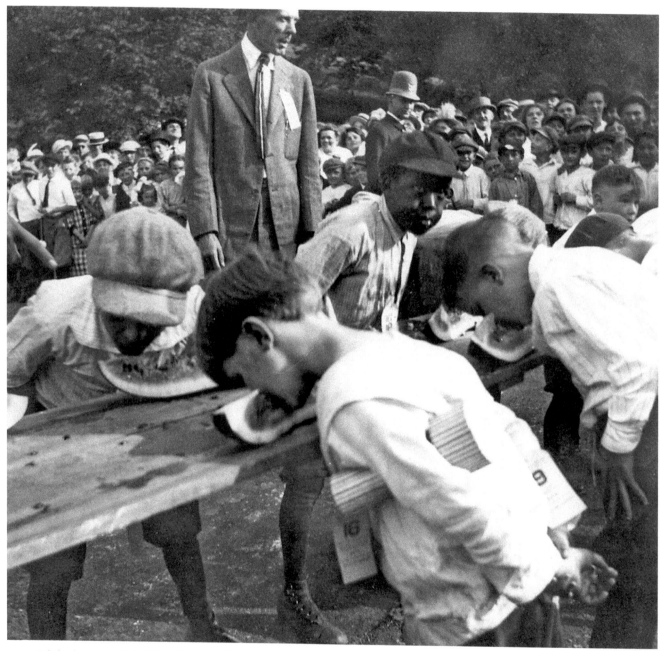

While the reservoir in Eden Park was drained and cleaned in 1915, a great municipal dance and picnic was held in the empty shell. Crowds watch the watermelon-eating contest.

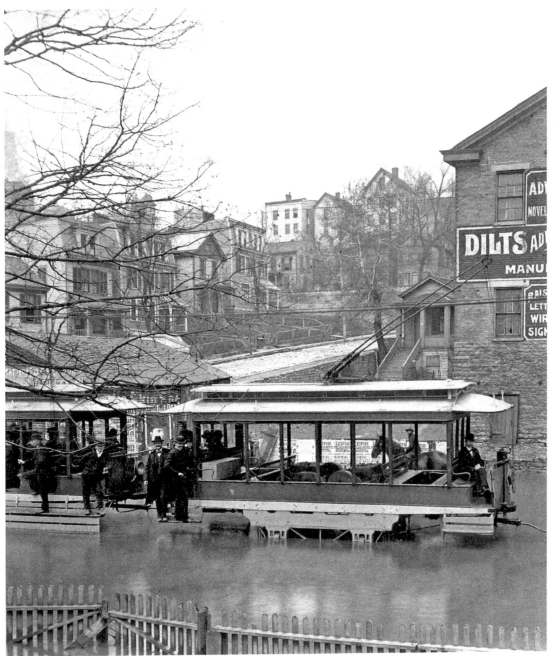

High-water streetcars had their motors mounted up in the body of the car, which was elevated from the tracks, as these cars illustrate in 1915 on Queen City Avenue.

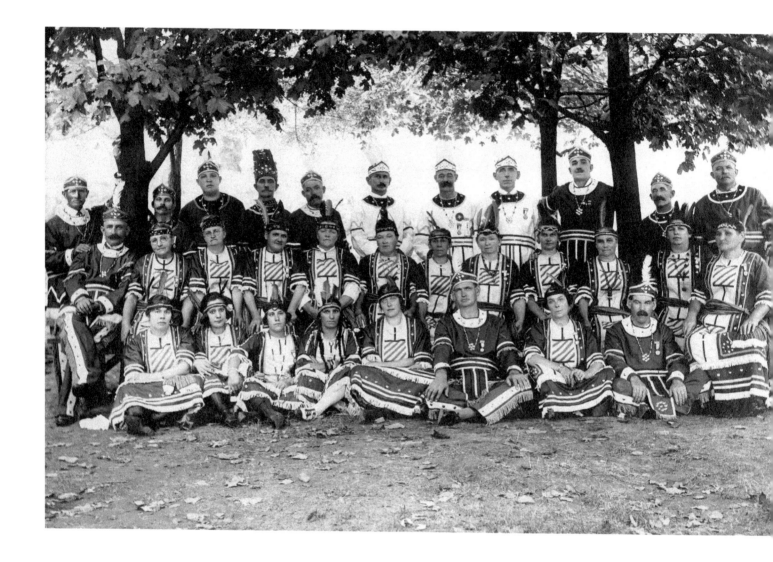

During the War of 1812 some patriotic Americans founded the Society of Red Men. They took their symbolism from Native American life and on festive occasions dressed in Native American costumes. This is one of the Cincinnati "tribes" of the Improved Order of Red Men about 1916.

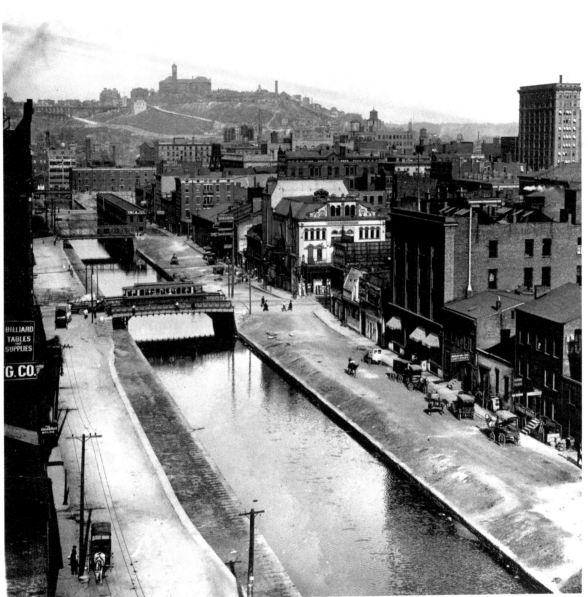

Facing east on Canal Street in 1916, now Central Parkway. The German community referred to crossing the canal as going "over the Rhine."

In 1917 and 1918 the convict ship *Success* toured the major ports along the Ohio River. Built in 1790, the *Success* transported felons from England to Australia. The exhibit was an object lesson in prison reform showing the barbaric conditions the prisoners endured.

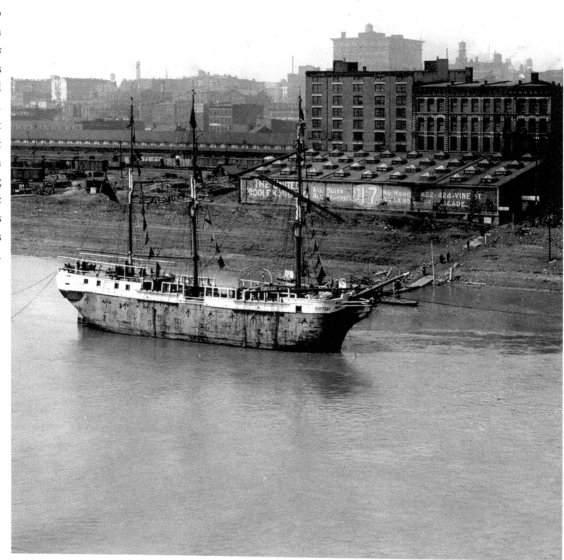

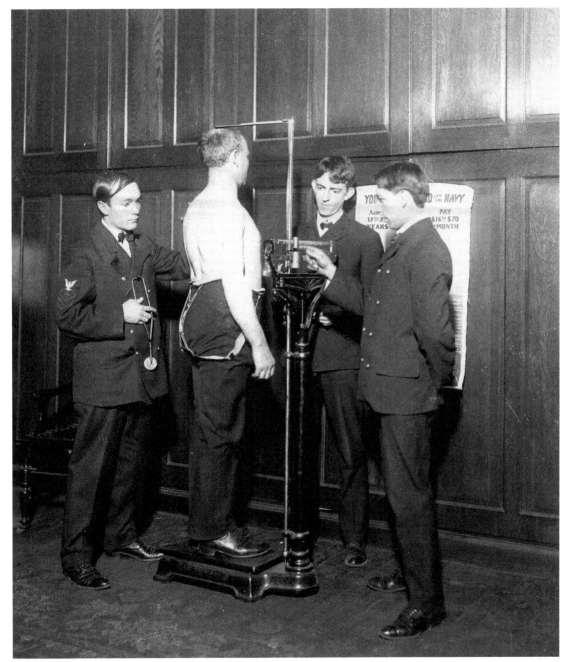

A recruit receives his physical examination before induction into the U.S. Navy following passage of the Selective Service Act in 1917. Servicemen could expect to earn $16 to $70 a month.

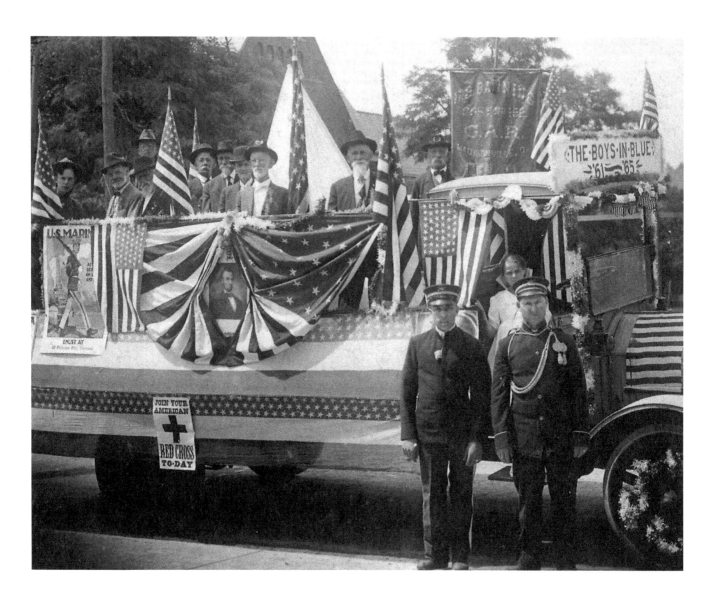

Veterans from Madisonville ride proudly in a World War I parade.

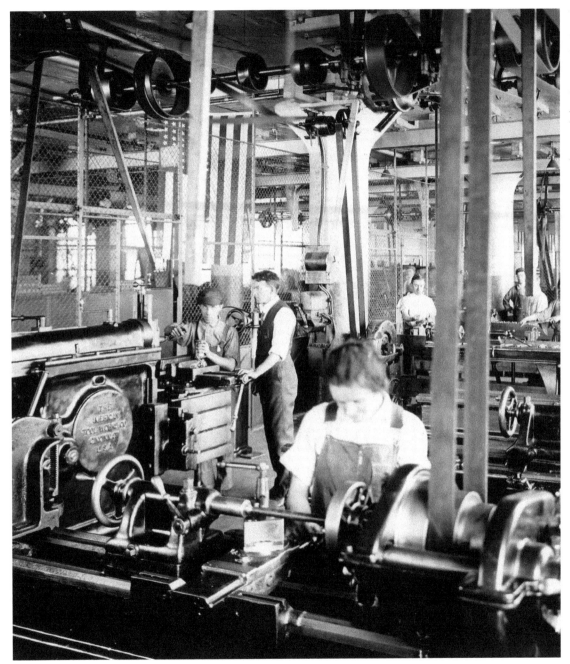

The Stars and Stripes adorning this work area reveal the patriotic spirit of the American Tool Works employees during World War I.

"Farewell Day" was observed August 23, 1917, when 3,000 Ohio National Guardsmen passed in review on Government Square on their way to service in the First World War. Tears mingled with cheers as more than 1,000 Cincinnatians gathered to say good-bye as the soldiers boarded trains for southern training camps.

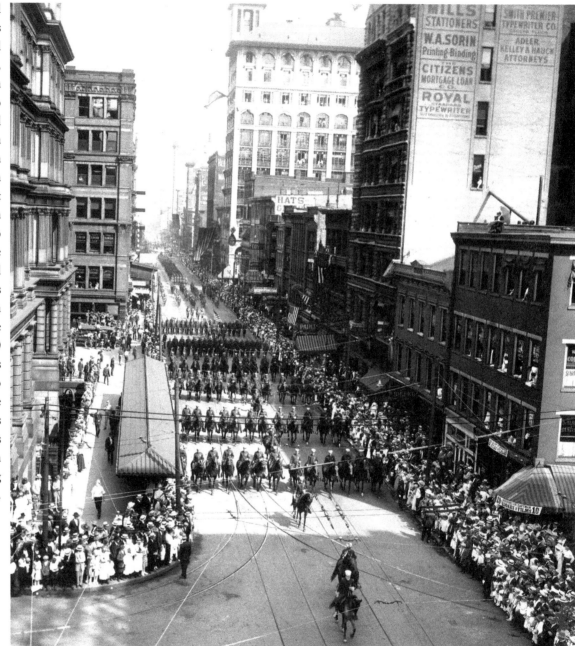

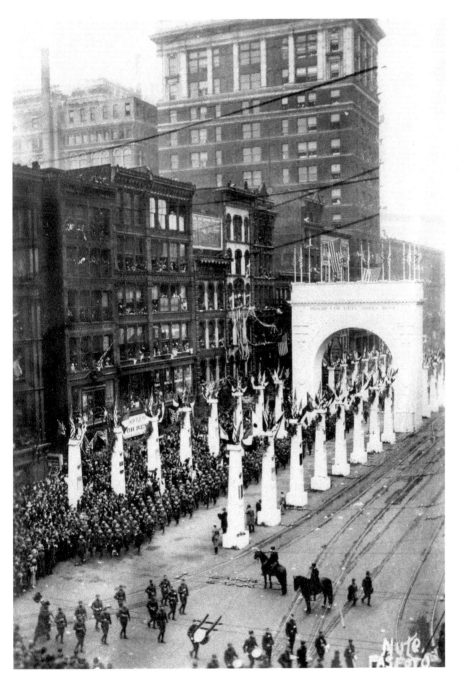

Soldiers returning from Europe following the war march beneath the majestic Arch of Triumph and through the Court of Honor on Government Square in April 1919. From atop the 48-foot high arch fly the flags of the United States and her allies. The pillars of the Court of Honor bear shields containing the names of the battles in which the soldiers fought.

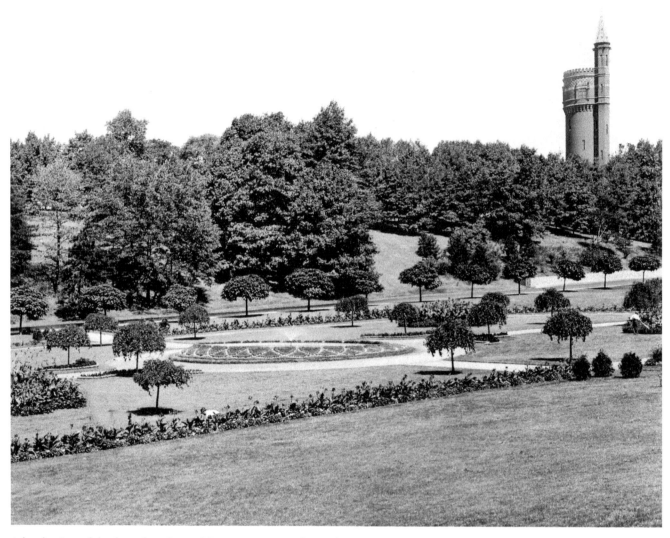

A lovely view of the formal garden and fountain seen in Eden Park around 1922. Built in 1894, the brick Water Tower in the distance was used as a pressure tank to supply water to Walnut Hills. During World War I the tower served as a guardhouse for infantry regiments encamped in the park.

FROM THE ROARING TWENTIES TO THE GREAT DEPRESSION

(1921–1939)

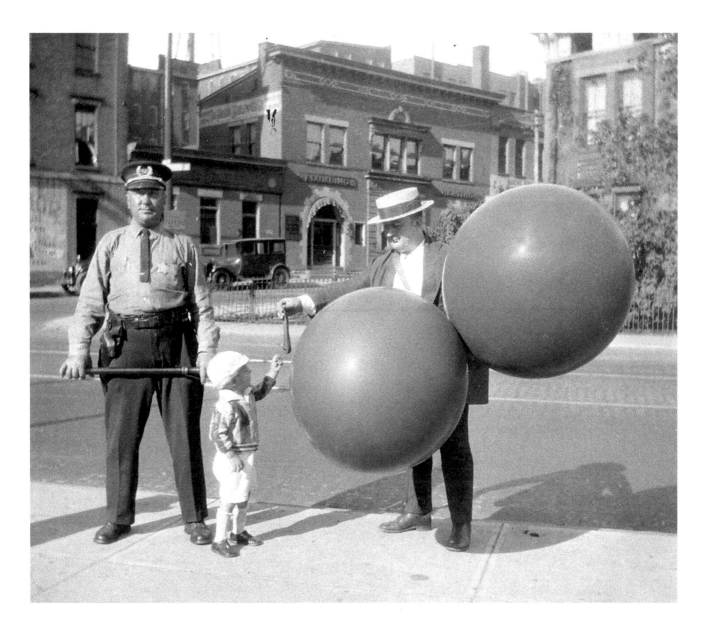

A balloon man and his young client conduct business outside Redland Field in 1929.

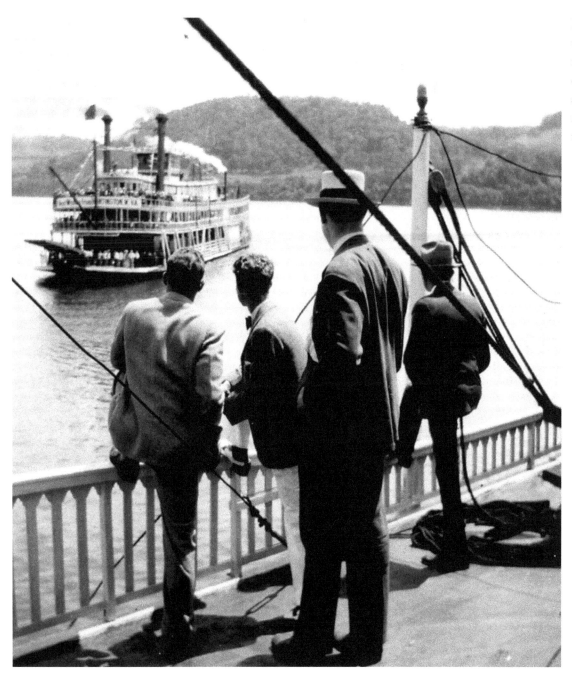

Looking across to the *Tom Greene* from the deck of the *Betsy Ann* at the start of a race between the two boats in July 1930.

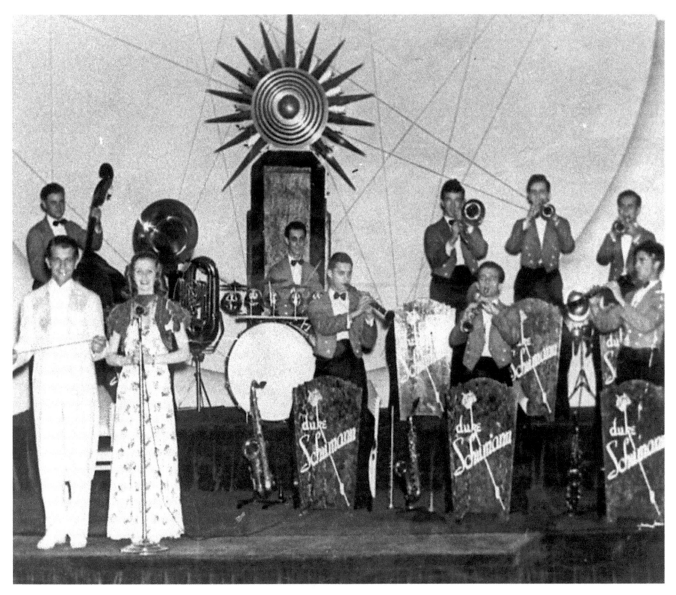

Cincinnati native Doris Day and Jerry Doherty with the Duke Schumann Band perform at the Pavillon Caprice in the Netherland Plaza Hotel in 1938.

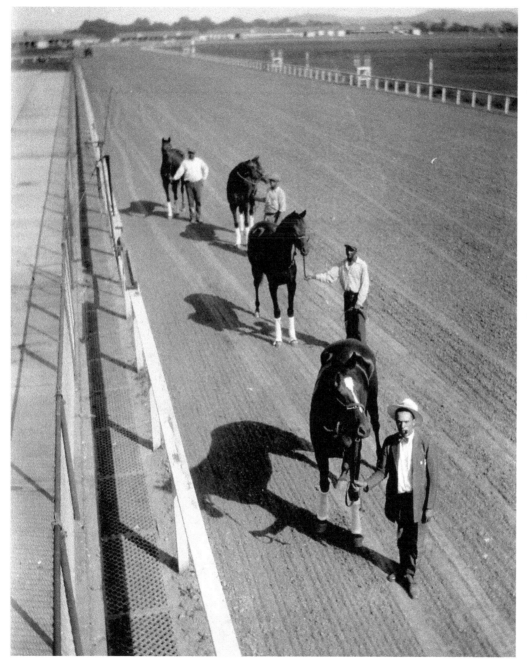

Horses are exercised along the oval track of the new Coney Island Race Course in 1925. A year later it was shut down for illegal gambling. It opened again in 1933 only to close again in 1935 due to the effects of the Great Depression and competition from the Latonia track. River Down's took it over in 1936 and it has remained open ever since.

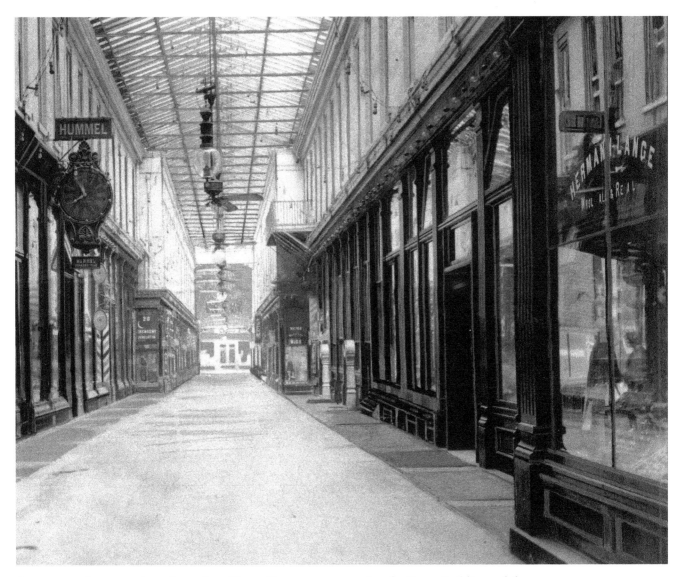

A two-story, glass covered arcade ran from Vine to Race streets connecting the Carew Building and the Emery Hotel from 1889 to 1929 and housing many of the city's fine jewelers and other retail outlets. An arcade was retained when the Carew Tower was built.

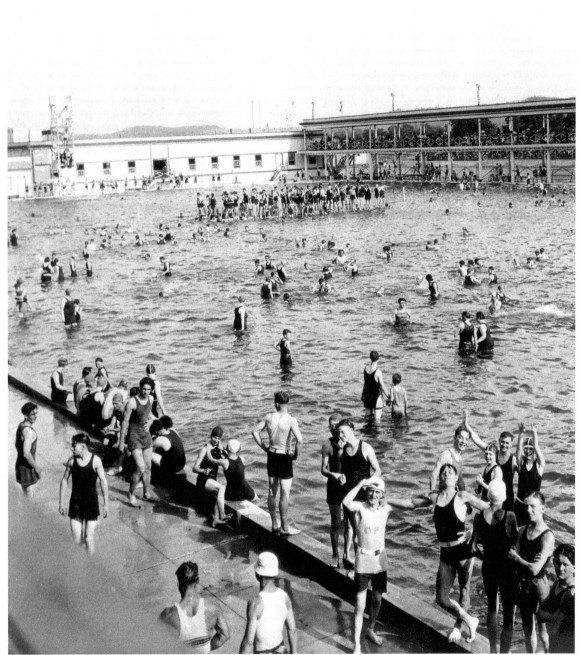

In 1926 a swimming pool opened at Coney Island. It was the largest recirculating water pool in the world, measuring 200 by 401 feet and holding 3.5 million gallons of water. An adult could swim with a rented suit and towel for 50 cents (children for 25 cents). Suits and towels were "sterilized" between uses. It was first called Sunlite Pool in 1938.

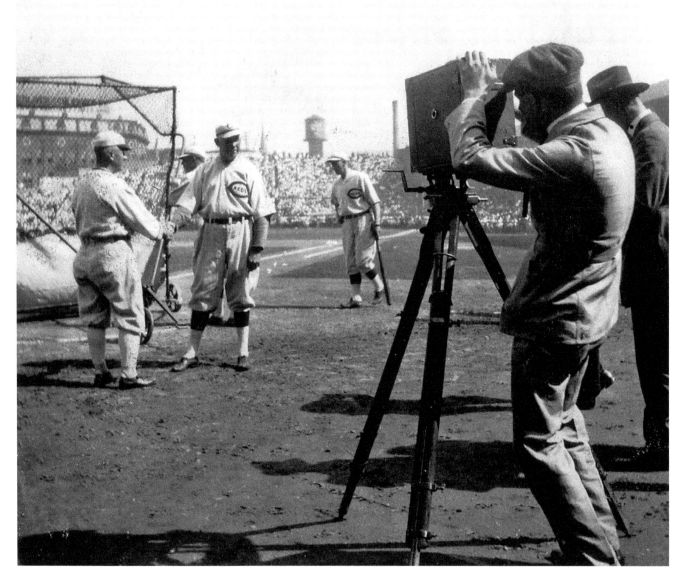

Camera crews are shooting Reds team members on the playing field of Redland Field in 1932.

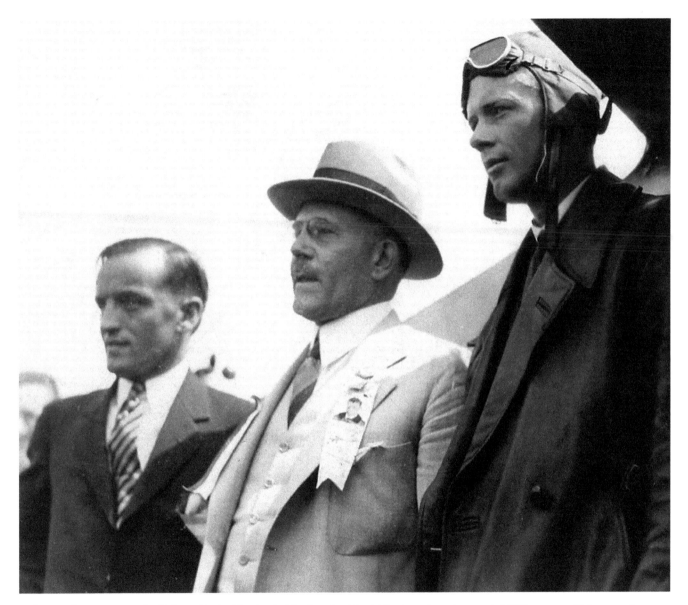

Following his nonstop solo flight to Paris, Charles A. Lindbergh visited Cincinnati on August 6, 1927, as part of his tour of American cities to promote aviation. "Lindy" was greeted by thousands of Cincinnatians, eager to get a glimpse of the famed aviator and his equally famous *Spirit of St. Louis* monoplane at Lunken Airport.

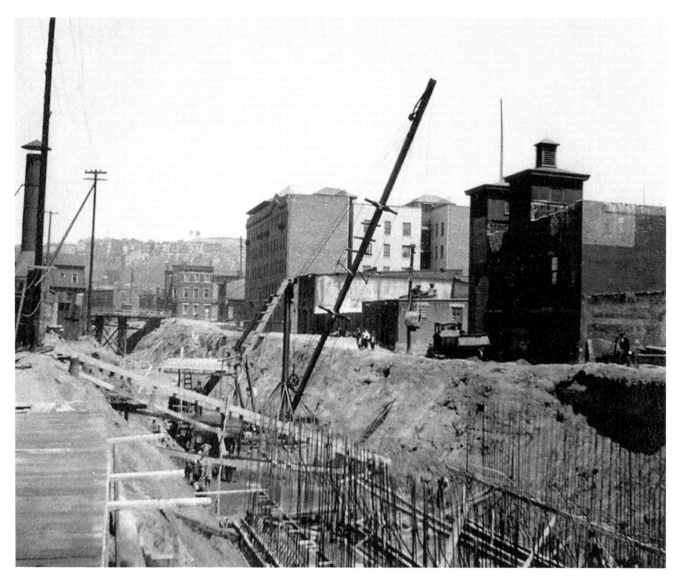

Tunnels for the city's new subway system were under construction at Plum and Canal (Central Parkway) in 1921. Construction stopped in 1925 when funds from a bond levy ran out. The project was abandoned in 1927 when no additional funding could be obtained. Less than half of the 16-mile planned route was completed. Only two miles of the underground facility remain today.

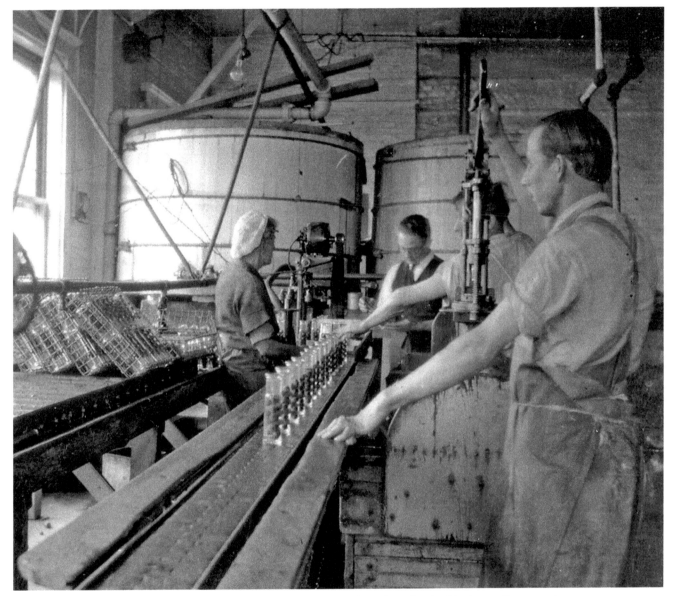

Cincinnati isn't generally known for olives, but these workers are packing them for the Lippincott Company in 1923. The Lippincott Company was nationally known from 1901 to 1942 for packing tomato products, pickles, and preserves, as well as olives.

Chesapeake and Ohio's *George Washington*, one of the nation's first fully air-conditioned trains, is shown pulling out of Union Terminal bound for Washington, D.C. A version of it bearing the George Washington name, linked Cincinnati and Washington from 1932 until 1971 when the service was taken over by Amtrak.

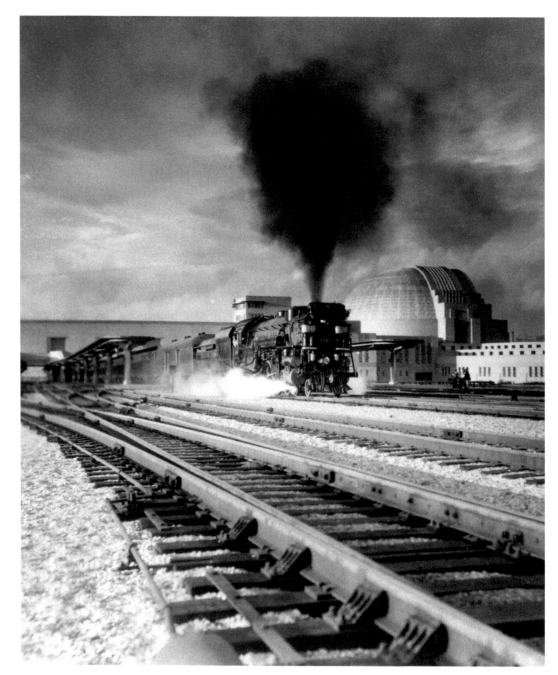

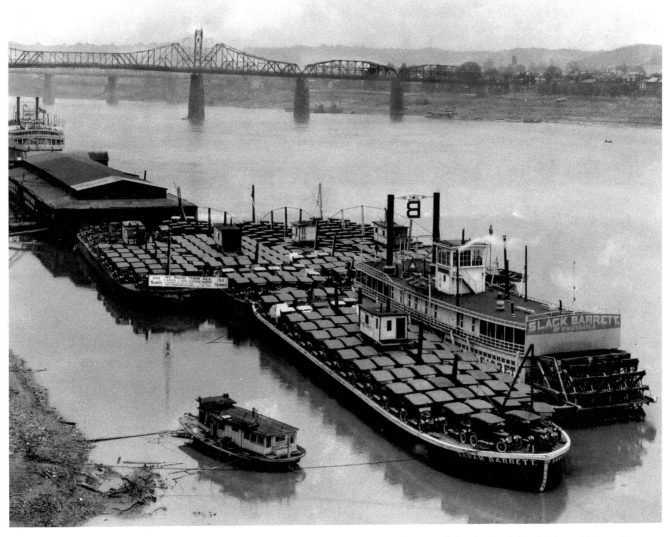

The steam towboat *Slack Barrett* sits at the Cincinnati wharf with five barges of automobiles destined for the Laurel Street Auto Laundry and Garage around 1920.

Cars are double-parked on Eden Park Drive as concert-goers attend the Caruso Memorial Concert in 1921.

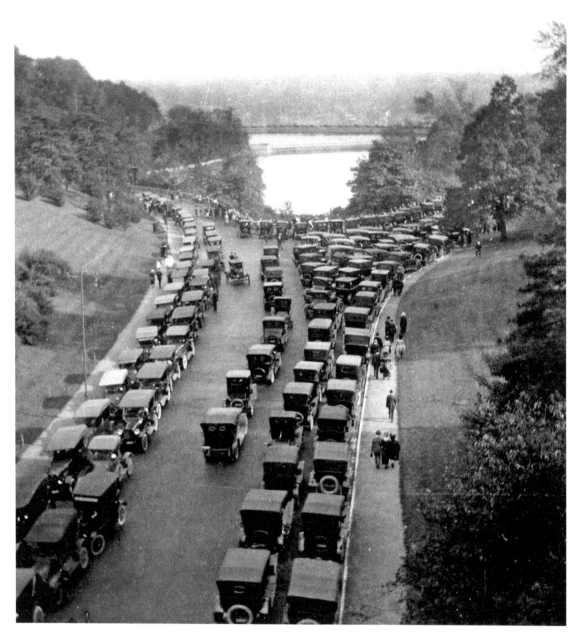

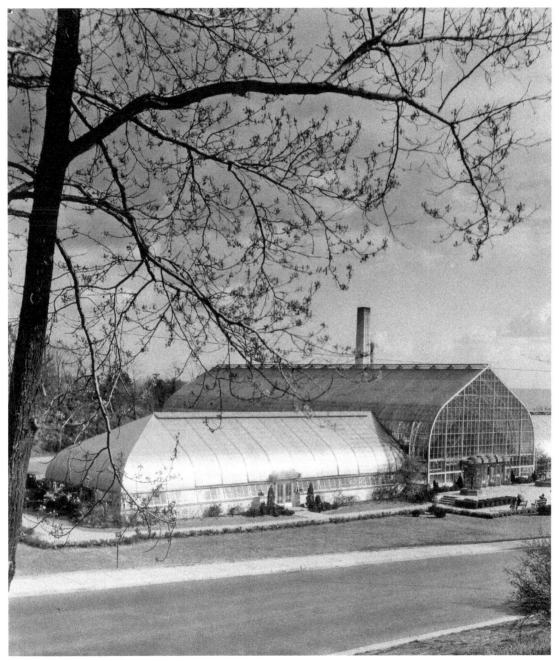

The new Eden
Park Conservatory
opened in 1933.
In 1937 it was
renamed the
Irwin M. Krohn
Conservatory
to honor the
President of the
Board of Park
Commissioners
and longtime park
board member.

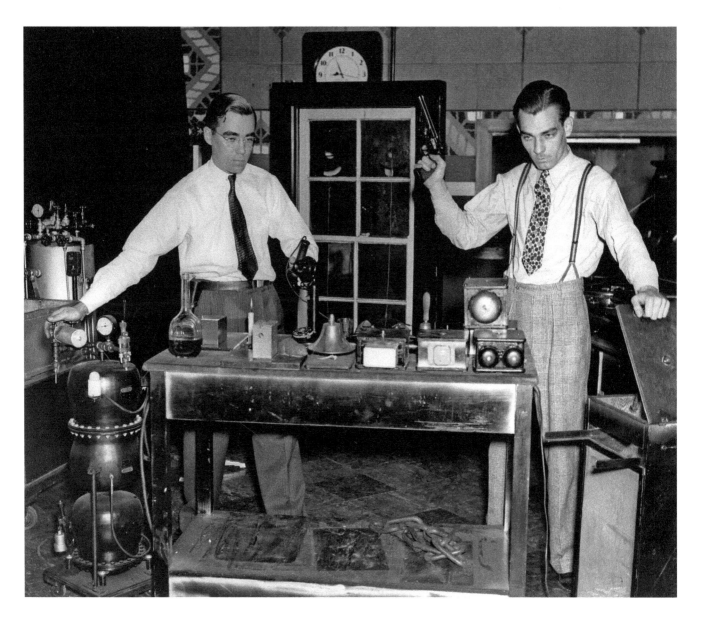

Sound effects played an important role in radio programs. WLW had one of the largest and most complete sound departments in the industry.

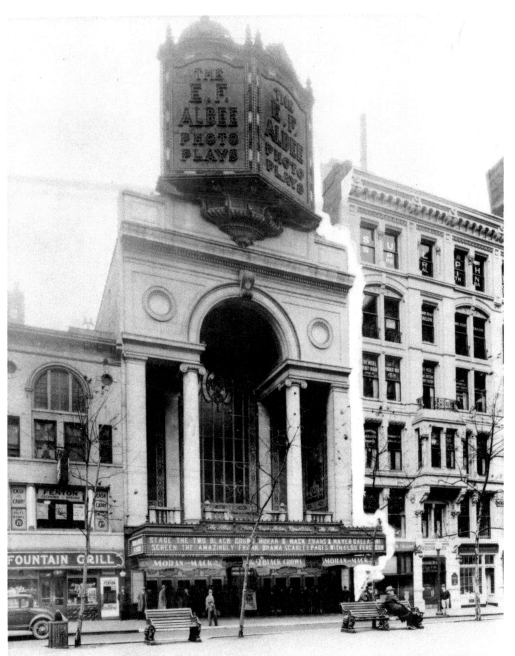

Theater-goers stand in line in 1930 to enter the Albee Theater. The Albee was popular because of its superb acoustics and clear view of the stage. When the theater was torn down in 1977 the classic Roman facade was saved and added to the Cincinnati Convention Center.

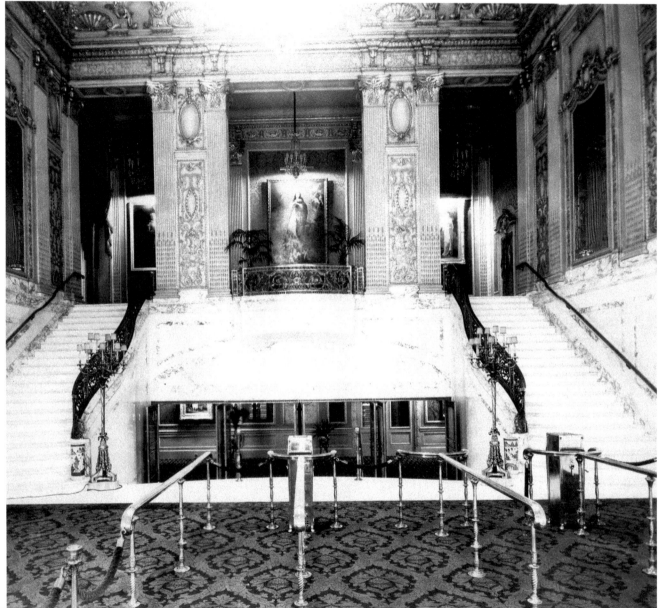

The opulent theater architecture of the 1920s is exhibited here in the lobby of the Albee Theater. Twin marble staircases led from the lobby to the mezzanine lined with original oil paintings and crystal chandeliers.

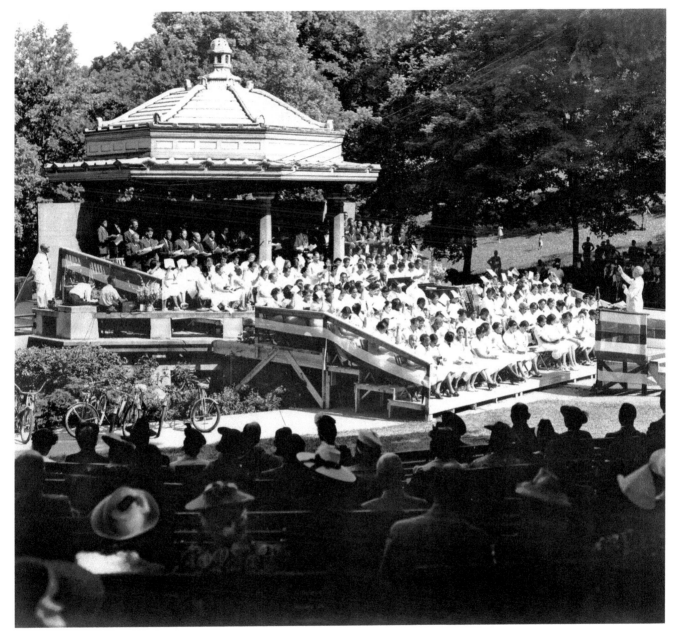

The annual Festival of Negro Music was sponsored by the Cincinnati Recreation Commission. The three hundred mixed voices were recruited from choirs, glee clubs, and choruses around the city and are shown here at the festival in Eden Park in 1939.

The first professional night baseball game took place at Crosley Field on May 23, 1935, between the Reds and the Philadelphia Phillies. President Franklin D. Roosevelt "threw the switch" on the 632 lights remotely from the White House. Over 130,000 fans attended the seven night games that year.

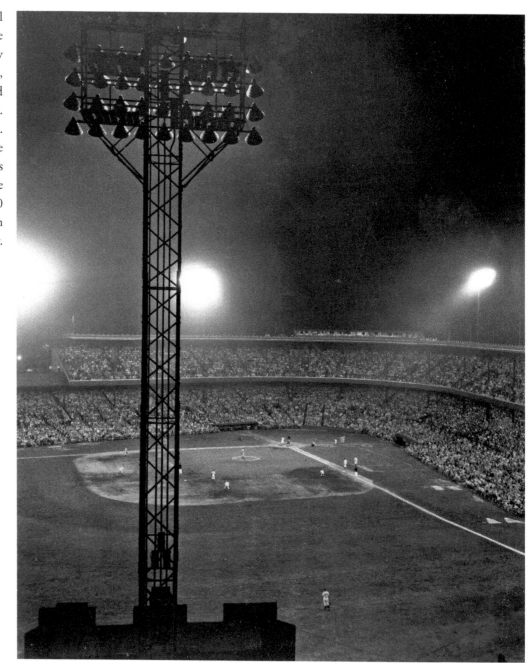

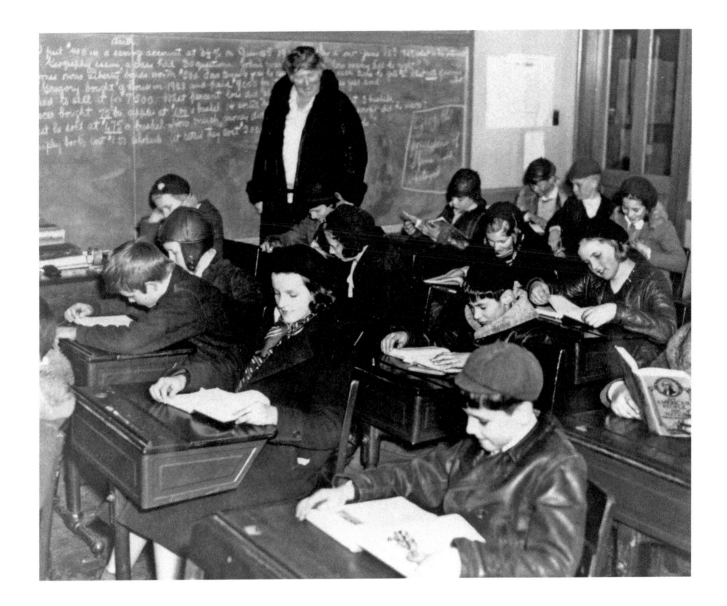

The Clifton Open Air School was started by Mrs. Helen Lotspeich. She was an enthusiast of fresh air and its presumed beneficial effects on health. For that reason there was no heat in the school and the windows were kept open. A new Lotspeich school was built in 1930, which had heat but the windows were still kept open.

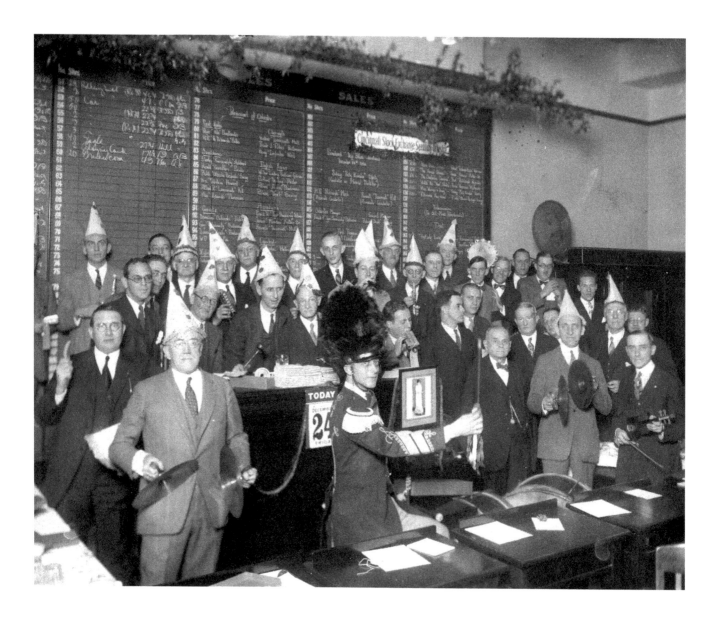

On Christmas Eve 1926, three years before the stock market crashed, Cincinnati Stock Exchange members celebrated by creating the "Seemfunny Orkestra" and performing a program of skits and songs.

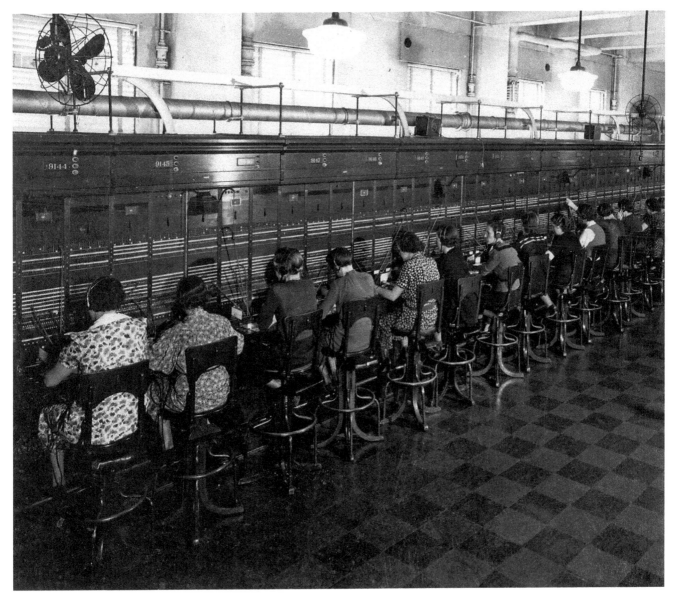

These are half of the 88 positions of the world's longest straight long-distance switchboard. On January 22, 1937, it handled a record 9,722 outgoing calls.

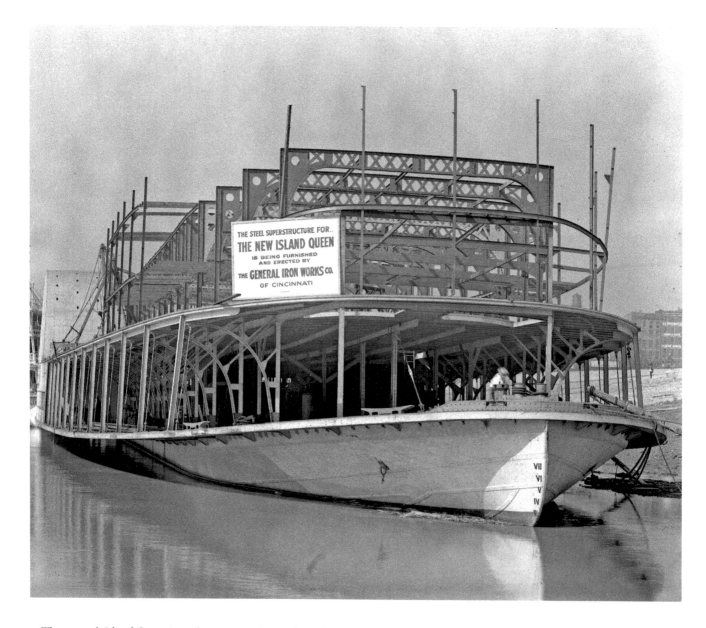

The second *Island Queen* is under construction at the Public Landing in 1924. This excursion boat was completed and dedicated on April 18, 1925. During the summers, the *Island Queen* carried passengers between the Public Landing and Coney Island amusement park. During the off-season she made "tramp trips" between Pittsburgh and New Orleans. On September 9, 1947, the *Island Queen* exploded and burned at Pittsburgh.

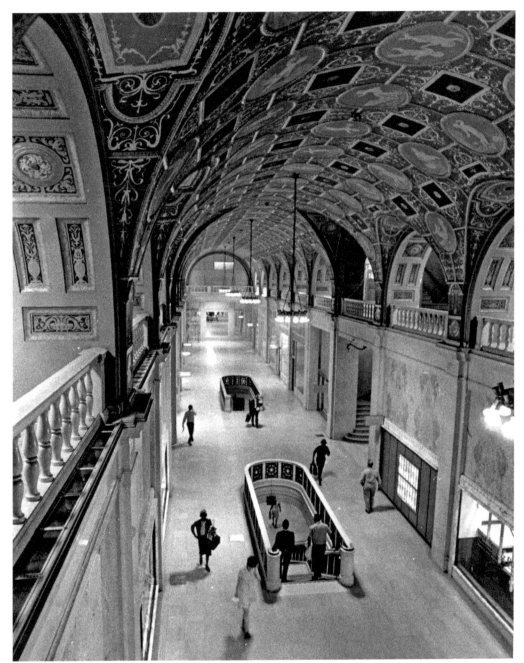

"Gateway to the South," the Dixie Terminal was built in 1921 and functioned as a terminus for buses and streetcars between Cincinnati and Northern Kentucky. Designed in the Italian Renaissance style, the terminal's interior arcade combines beauty and function.

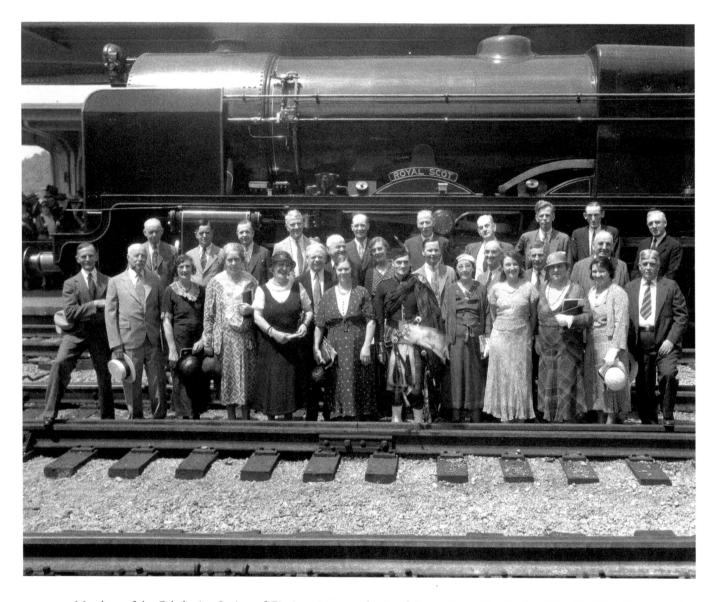

Members of the Caledonian Society of Cincinnati inspect the *Royal Scot* at Union Terminal on May 24, 1933. Transported overseas from Great Britain, this locomotive of the London, Midland & Scottish Railway was en route to Chicago to be placed on exhibit at the Century of Progress Exposition. The Caledonian Society was organized in 1827 to annually celebrate the birthday of Scotland's patron saint, Saint Andrew, and to also provide funds for needy Scottish immigrants coming to Cincinnati.

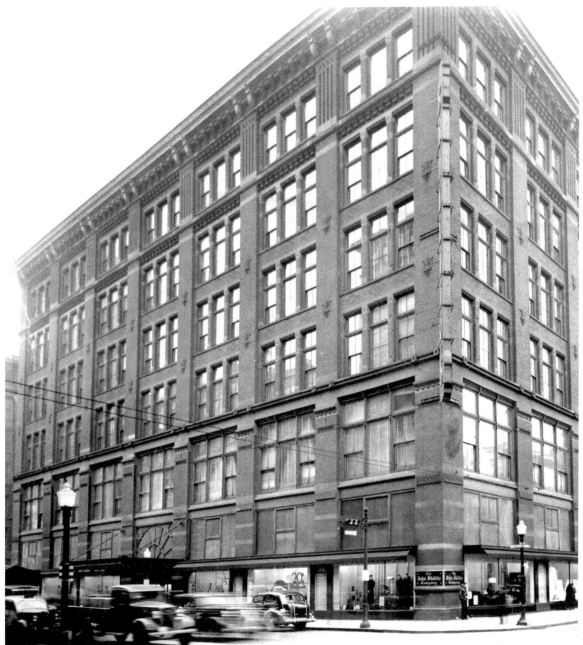

The John Shillito Company at Seventh and Race streets as it looked just prior to its "face-lift" in 1937. Modernization of this department store included a nine-story addition, air-conditioning, and a new facade.

Crosley Square was the home of WLW Radio, the nation's first 50,000-watt commercial broadcasting station to operate on a regular schedule in 1928. From then on it was known as "The Nation's Station."

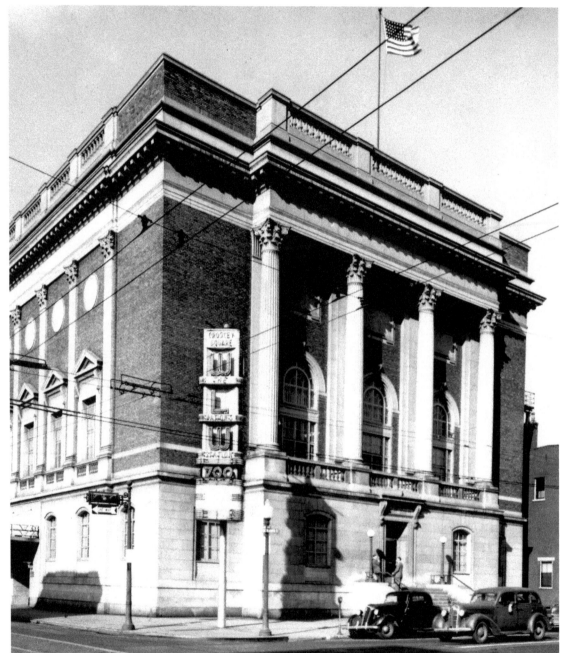

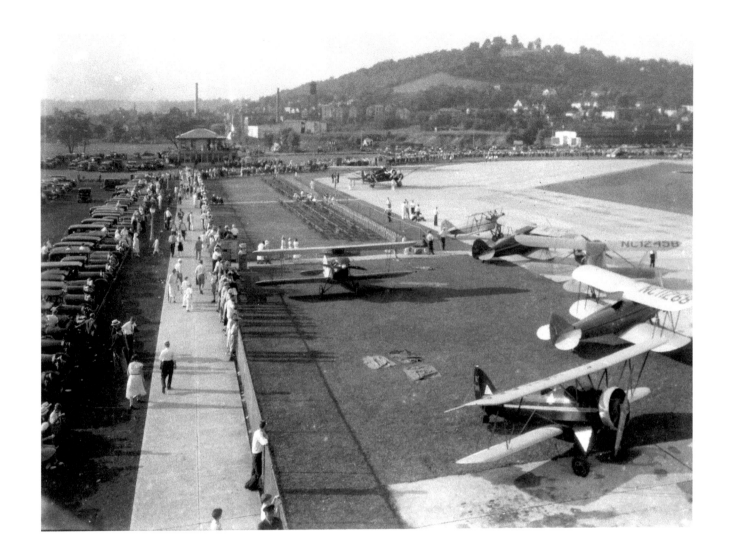

Ohio-made Waco biplanes and a Stinson Tri-Motor grace the ramp at Lunken Airport during a public event in the early 1930s. The original administration building is visible at left, replaced by a new building in 1937.

Children linger beneath the roof of Findlay Market in 1935. Named after civic and military leader James Findlay, this market began providing fresh produce and meat to the residents of Over-the-Rhine in the 1850s. Before there were supermarkets, people stocked their pantries at open-air markets in the old world tradition.

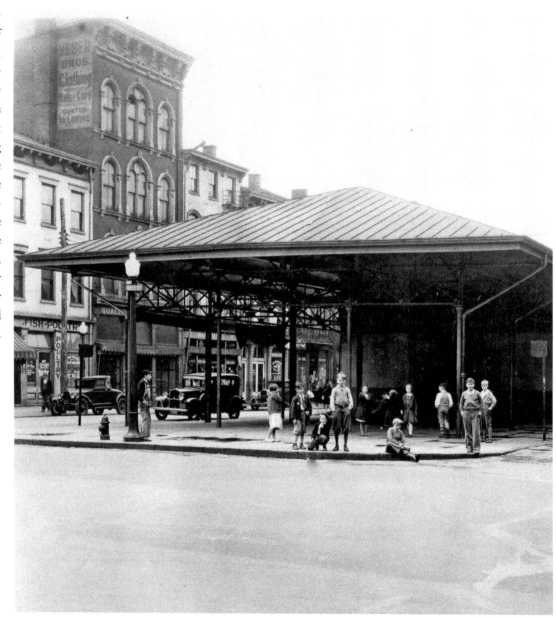

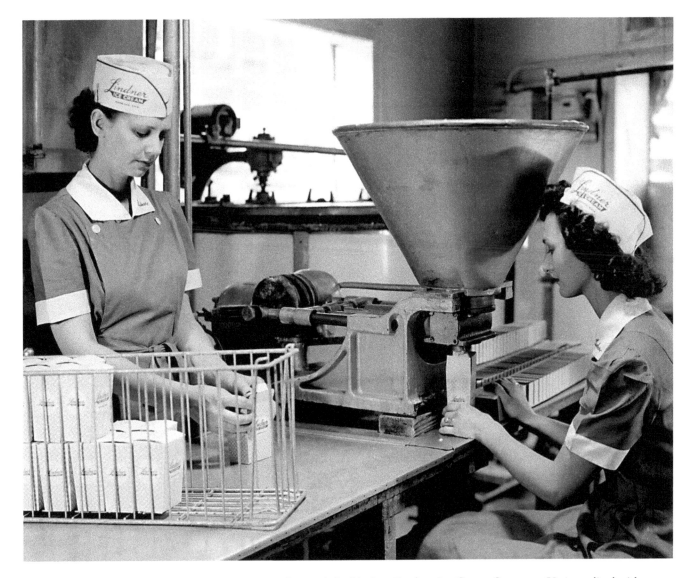

Carl H. Lindner, Sr., came to Cincinnati in 1931 and started the Lindner Brothers Ice Cream Company. He is credited with introducing the "triple-dip" ice cream cone to this area. He sold his interest in that company and in 1940 started the first United Dairy Farmers store.

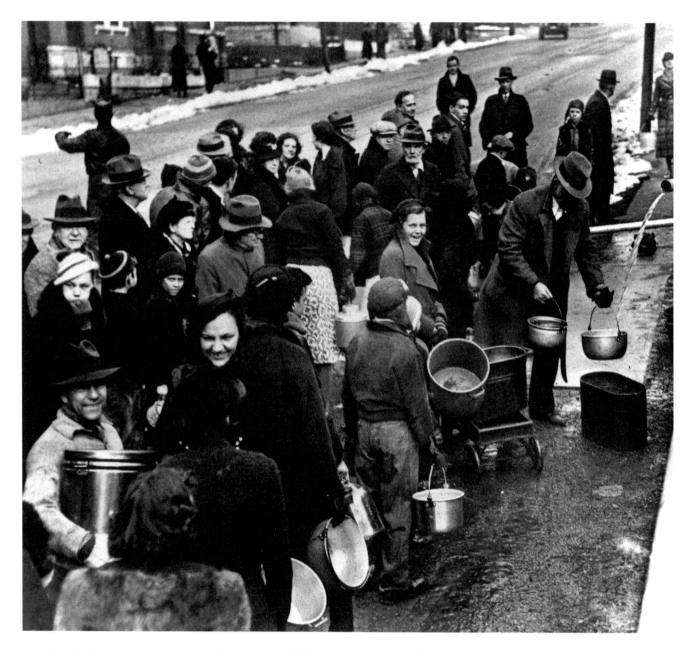

After the floodwaters receded in 1937, residents of Clifton Avenue stood in line for fresh water. The water still had to be boiled before drinking.

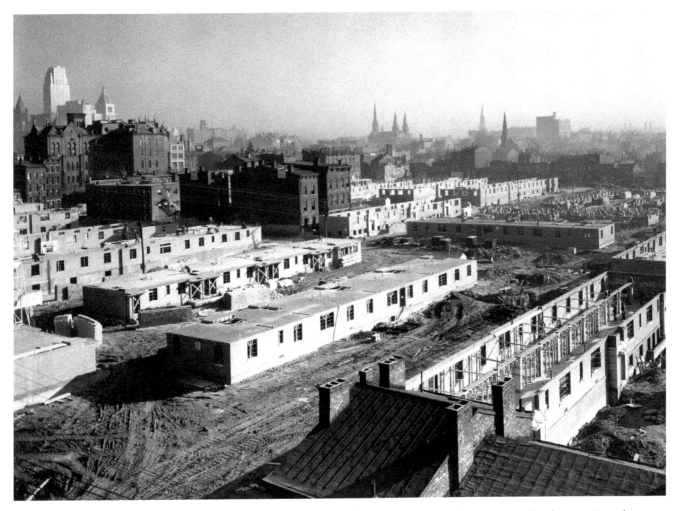

In the 1930s, the Public Works Administration made money available for construction of new housing for the poor. Laurel Homes, completed in 1938, was the first federal housing project funded through tax dollars in Cincinnati. Initially it housed mostly low-income white families but additional units were added later for black families.

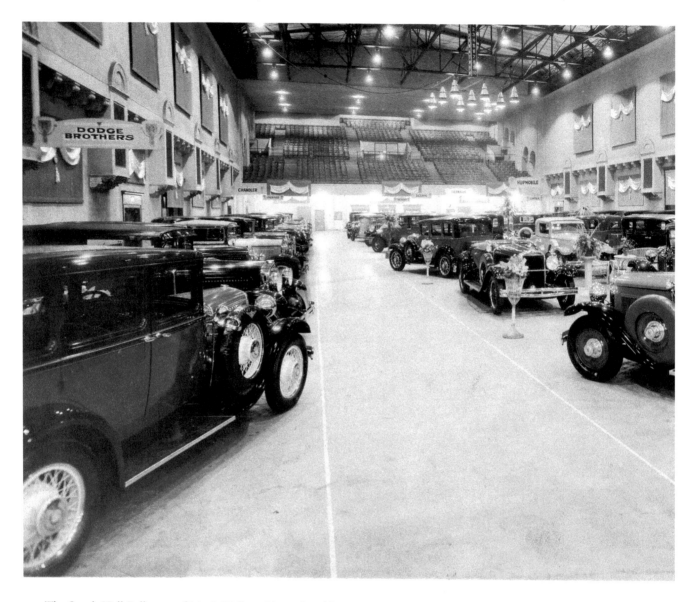

The South Hall Ballroom of Music Hall could comfortably seat 1,800 for dinner or it could be transformed into an exposition center. The wide aisles, good lighting, and drive-in entrances provided a suitable showplace for these 1920s automobiles. Music Hall served as a convention and exposition facility until the construction of the Convention Center in 1967.

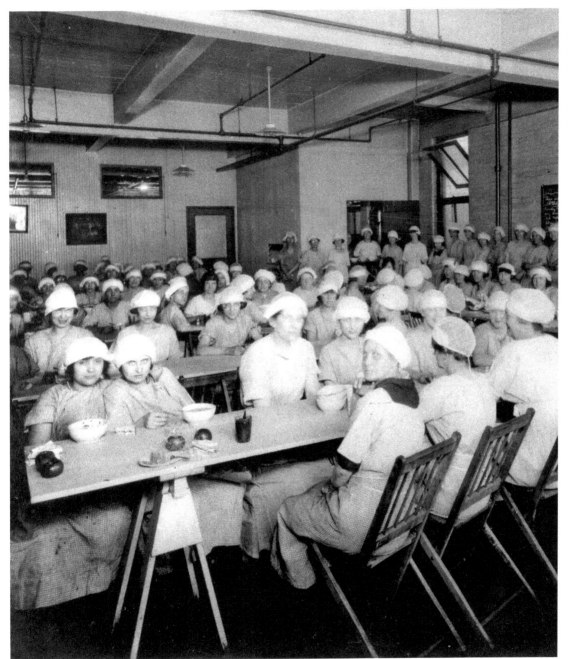

The women of Strietmann Biscuit Company take a lunch break from making crackers and cookies in the 1920s.

This was a source photo for the U.S. Playing Card Company industrial mural, one of fourteen Winold Reiss murals depicting area businesses and workers that hung in the Union Terminal concourse. A woman printer is shown in the 1930s photograph but she doesn't appear in the finished mural.

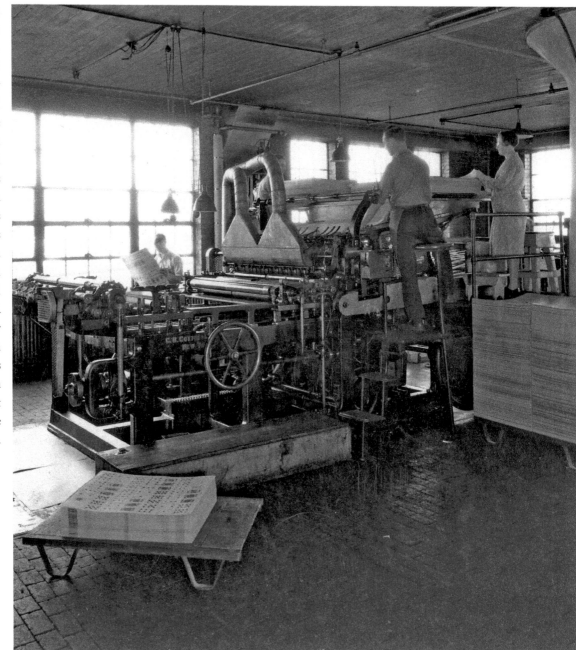

From World War II to the Emergence of the Modern City

(1940–1950s)

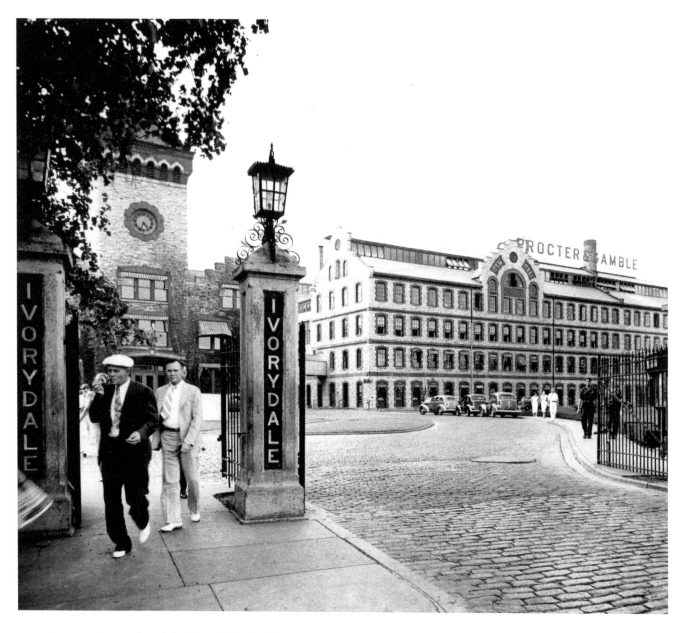

Construction on the original Ivorydale plant began in 1885. Over the years this manufacturing complex grew to contain 213 buildings over 61 acres and included a fire department, dining rooms, and recreational facilities.

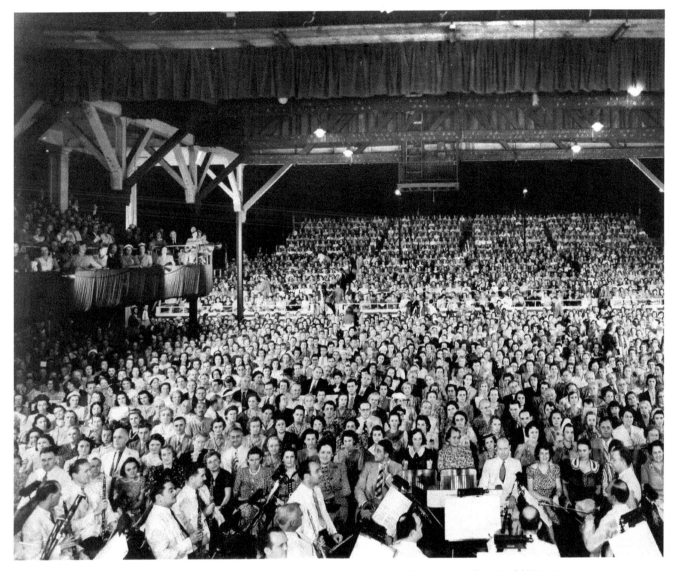

Summer opera at the Cincinnati Zoo started in 1920 as an experiment to revitalize the arts after World War I. Crowds like this one in 1941 jammed the pavilion for more than 50 years to hear the dulcet tones of rising stars like Beverly Sills, Rise Stevens, Placido Domingo, and Ezio Pinza.

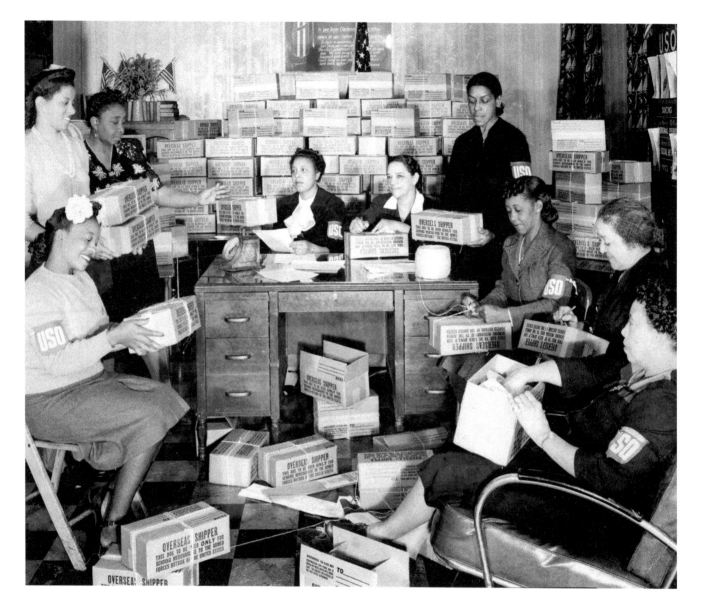

These African-American U.S.O. workers in the West End were part of a group responsible for packing more than 300 boxes of supplies to be sent to military service personnel overseas in 1944.

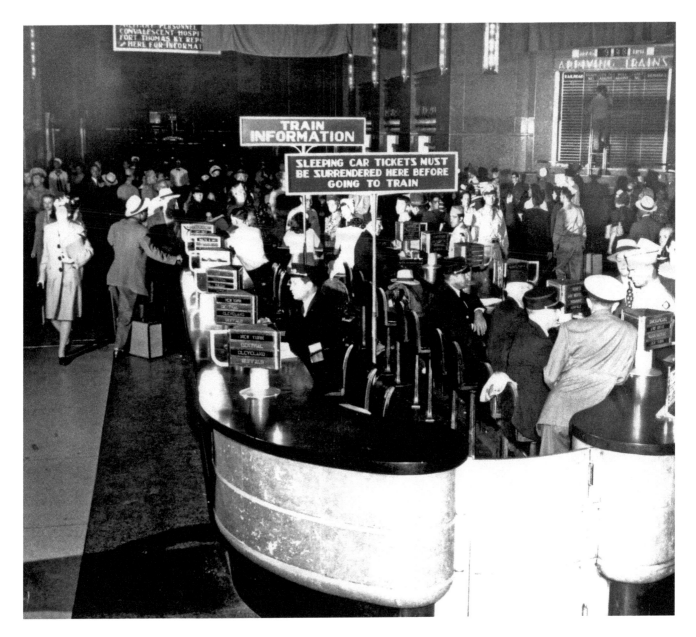

The need to move war personnel and restrictions on auto travel boosted passenger travel on the railroads during World War II. In 1944 an estimated 34,000 people traveled through Union Terminal each day.

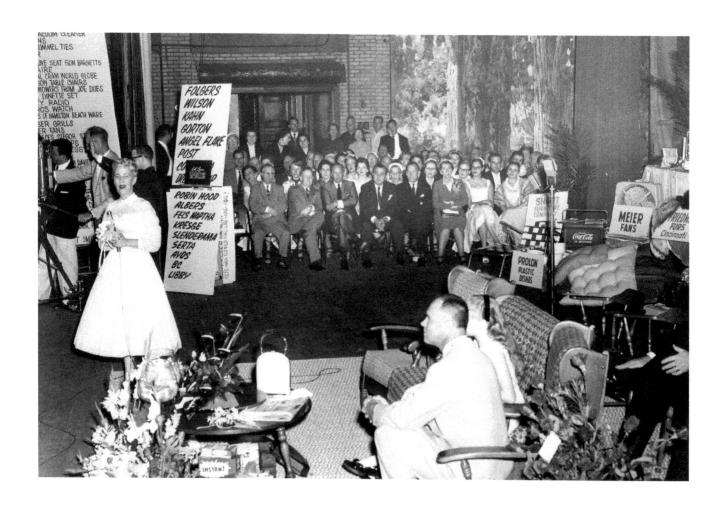

The Fifty-Fifty Club, with star Ruth Lyons, was one of the most popular daytime television shows in the 1950s and early 1960s. In 1957 it became the first local program to be broadcast in color.

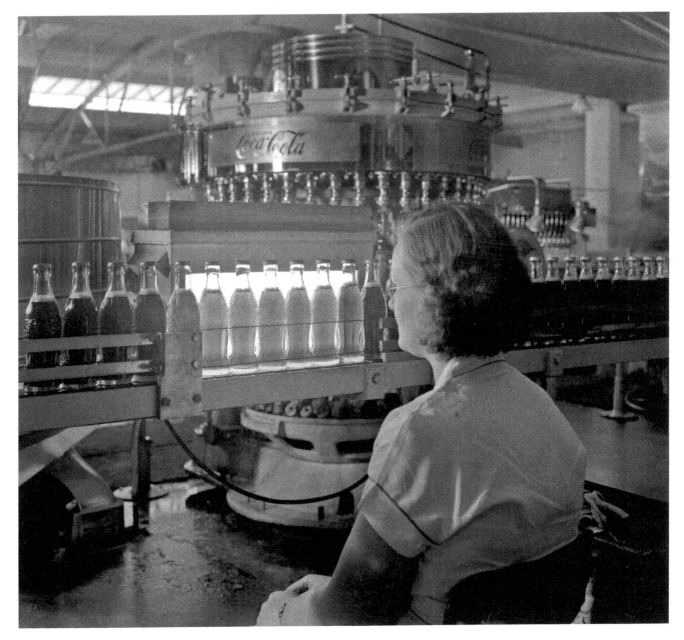

An inspector scrutinizes bottles of Coca-Cola in the 1940s as they pass in front of a piercing light. In the final step of production, each bottle had to meet exacting standards.

The
Maketewah
was one of
several open-
air streetcars
in the city.
Passengers
enjoy the fresh
air and city
lights from the
Mt. Adams
Incline in the
1940s.

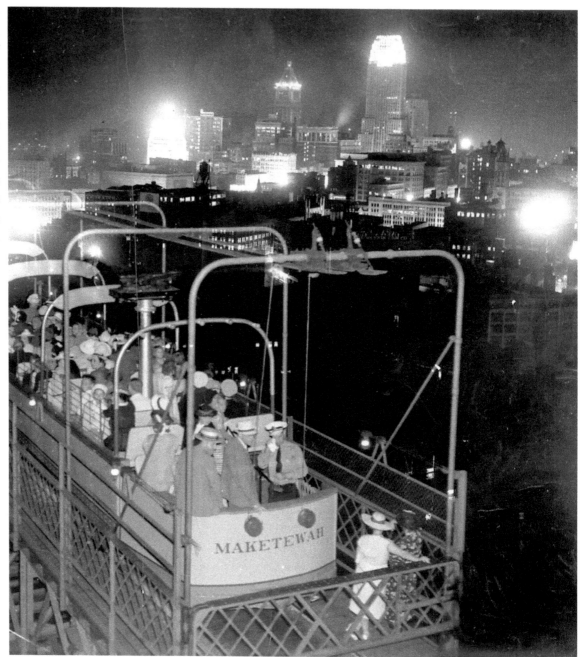

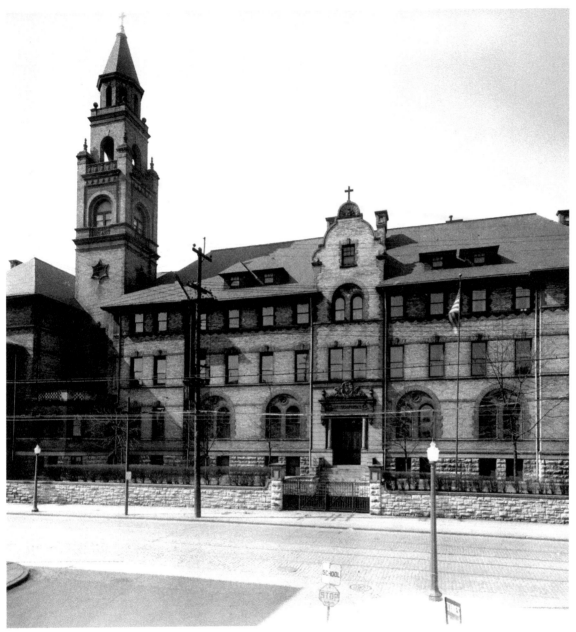

The Convent and School of the Sisters of Mercy on Western Avenue was designed by the architectural firm of Samuel Hannaford and Sons in 1885. Today it is home to the Job Corps Center, which offers academic and vocational training to men and women from low-income families. It is shown as it appeared in 1946.

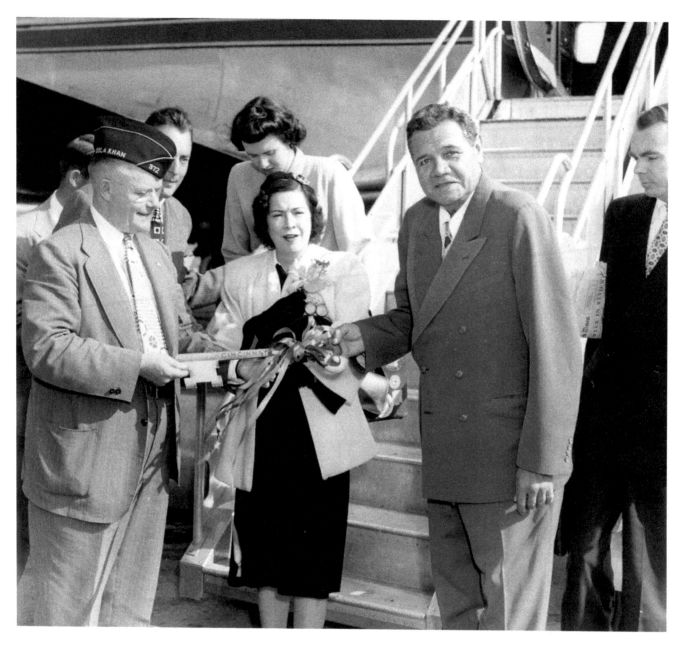

Babe Ruth accepts the key to the city from Mayor Carl W. Rich upon his arrival in Cincinnati in 1947 to attend the All-Star game. Ruth died the following year.

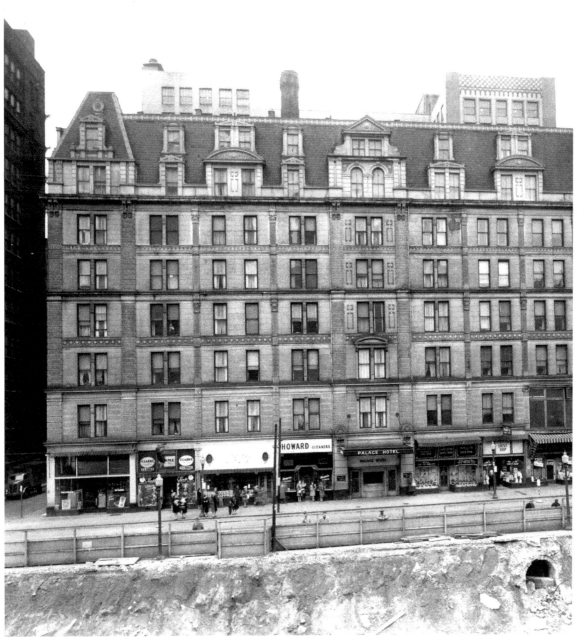

The Palace Hotel built in 1882 was designed by local architect Samuel Hannaford. Renamed the Cincinnatian in 1951, it was the first hotel in the country to have hydraulic elevators and incandescent lights.

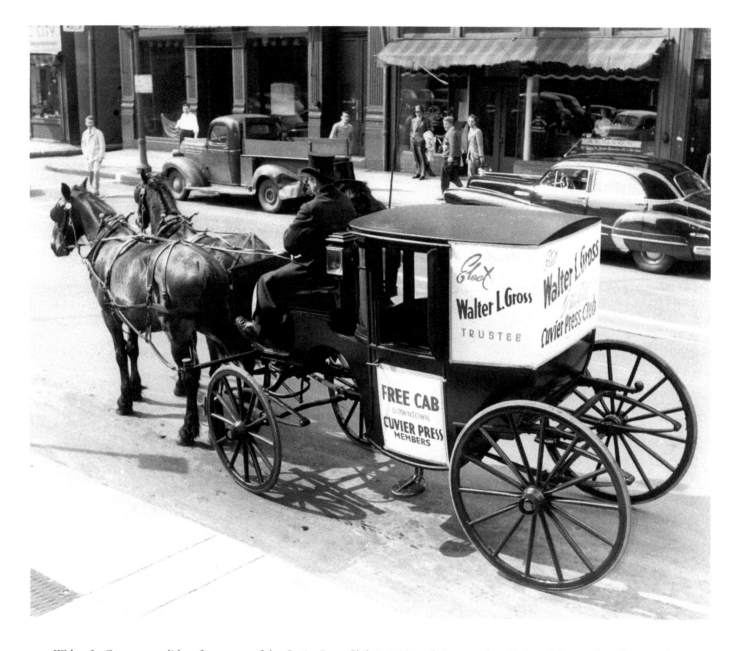

Walter L. Gross, a candidate for trustee of the Cuvier Press Club in 1947, solicits votes by offering club members free, two-horse-power cab rides between the club and downtown hotels.

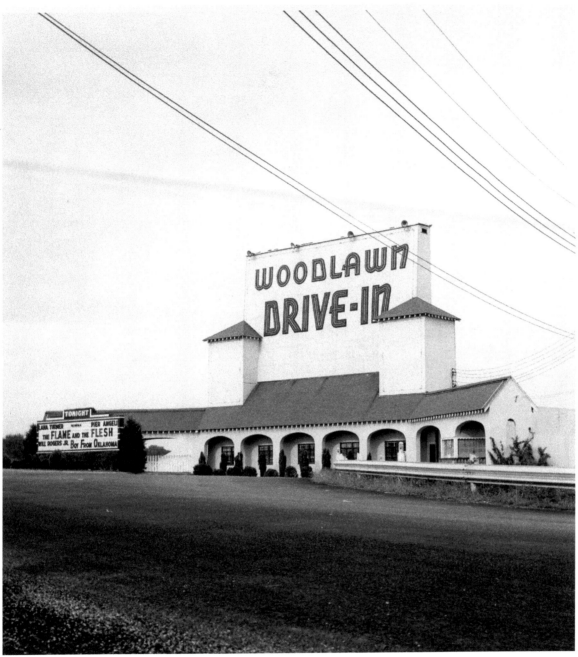

Before DVDs and videotapes, Mom and Dad would bundle kids in their pajamas, pack soft drinks and popcorn, and head for the drive-in movies. The Woodlawn Drive-in, built in 1947, was the second one in Cincinnati. In addition to the movie it featured a cafeteria, repair service for cars, and a playground for children.

The Third Street Distributor, now called Fort Washington Way, was proposed as early as 1925 in order to distribute traffic around the central business district. Work did not get started until passage of the Federal Highway Act of 1956. It opened in June 1961.

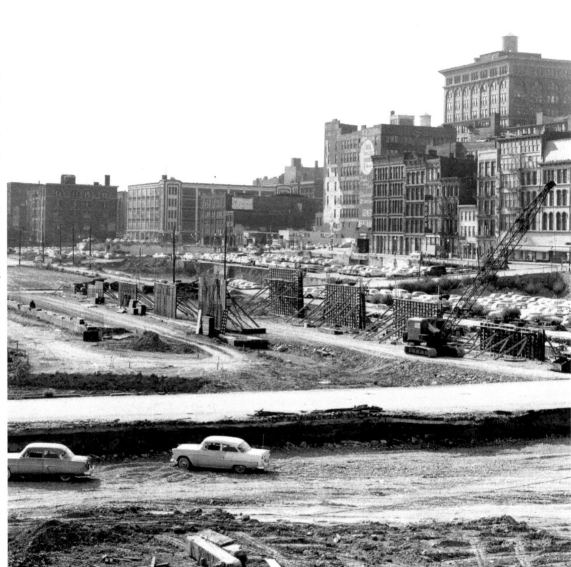

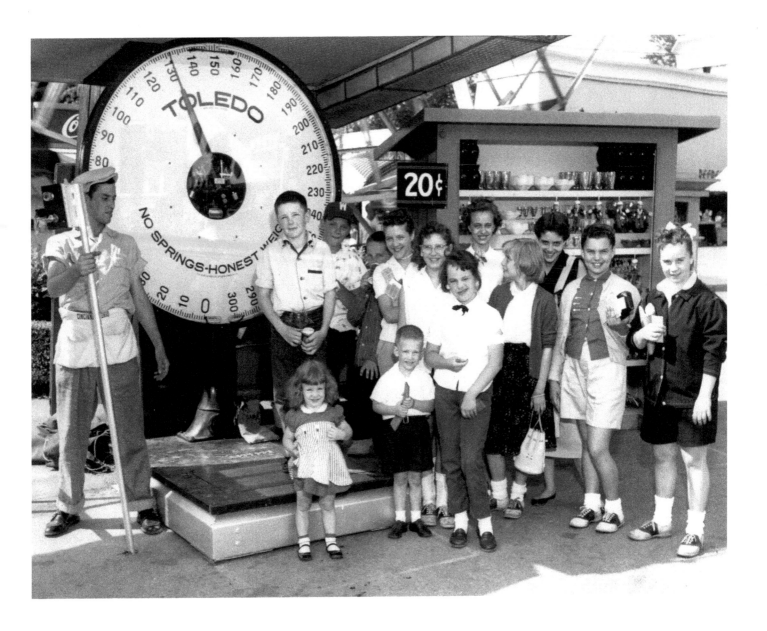

Children wait to have their weight guessed on the Mall at Coney Island in the 1950s.

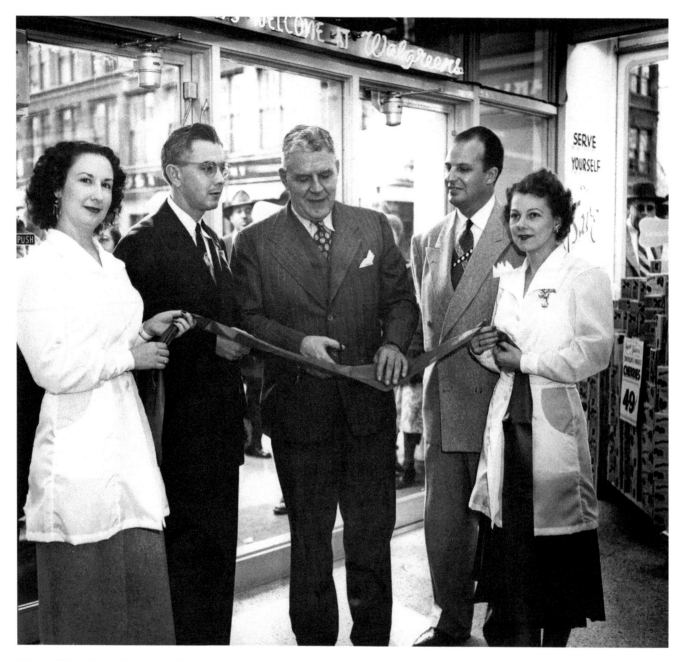

Mayor Albert D. Cash cuts the ribbon on October 30, 1950, to open the largest self-service Walgreen's Drug Store built to date.

NOTES ON THE PHOTOGRAPHS

These notes attempt to include all aspects known of the photographs. Each of the photographs is identified by the page number, photograph's title or description, photographer and collection, archive, and call or box number when applicable. Although every attempt was made to include all data, in some cases complete data may have been unavailable.